At A Distance #5
Exhibition in print

A project by Alastria Press
Summer 2021

The pieces in this exhibition were all created by an artist and a maker, working from separate locations using only written word as a means of communication. Each maker was responsible for interpreting instructions by the artist and completing the work in the most faithful and accurate way possible.

Walking Vexations
Selection from "840 Variations on Vexations"

by Lauren Sudbrink
made by Rumpelstiltskin Morgan

Performance, sculpture

The composer Erik Satie (1866-1925) may be considered an odd muse for our contemporary era. One of his lesser known, but influential compositions, *Vexations*, is a short piano work preceded with an instructional inscription: "*Vexations* should be played 840 times in succession, it would be advisable to prepare oneself beforehand, and in the deepest of silence, by serious immobilities." This "direction" lead to the interpretation that *Vexations* should be played 840 times in order to complete the performance of the piece as Satie intended. It is not known whether Satie's instruction was meant to be taken literally, but has nonetheless come to characterize performances of the piece, leading to marathon public interpretations by challenge-hungry and endurance seeking pianists. Looking to *Vexations* and its rule of 840 repetitions, I am developing a body of work that directly engages with Satie's score and its metaphoric subtext of arduous and stoic labor.

Walking Vexations is a selection from this larger project titled *840 Variations on Vexations*. This annotated list of 840 potential projects ranges from objects to events, happenings, performances to sounds, new music and recordings. Some of these projects have been executed, while others require community engagement to fulfill their potential. Through these projects I present conceptual and poetic responses to duration, endurance, labor, and artistic interpretation. The aim of this (eventual) publication is to provide possibilities and inspirations for artists and musicians considering their own roles in labor and the re-inscription of the creative process.

- Lauren Sudbrink

Vexations

ERIK SATIE

NOTE DE L'AUTEUR:
Pour se jouer 840 fois de suite ce motif, il sera bon de se préparer au préalable, et dans le plus grand silence, par des immobilités sérieuses

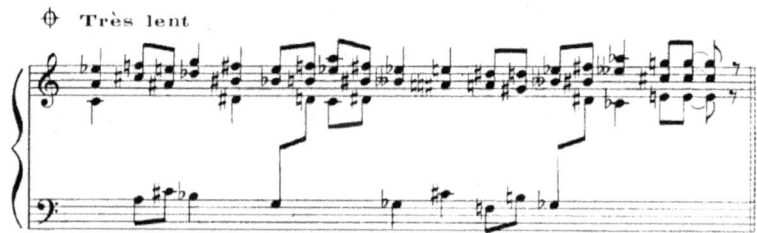

Très lent

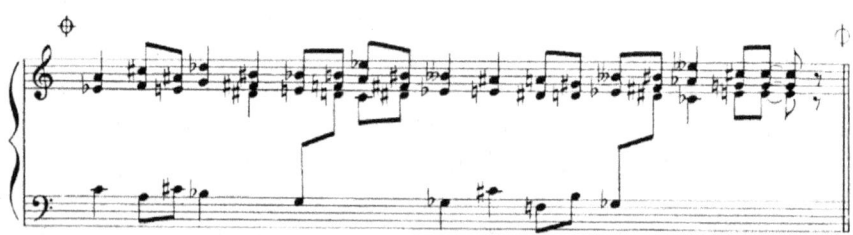

A ce signe il sera d'usage de présenter le thème de la Basse

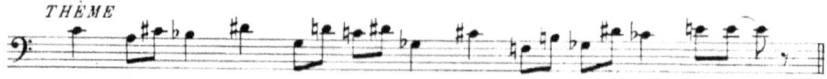

THÈME

Instructions:

1. While listening to Satie's Vexations, go for a walk or a series of walks
2. In the course of your walk or walks, collect 840 stones
3. Save the stones in a container of your choice
4. Feel the weight of Vexations
5. Record how many stones you collect on each walk
6. Document your final collection using photographs or film

Suggested Materials:

1. Score to Satie's Vexations for reference
2. Audio recording of Vexations
3. Container for stones
4. Patience and intention

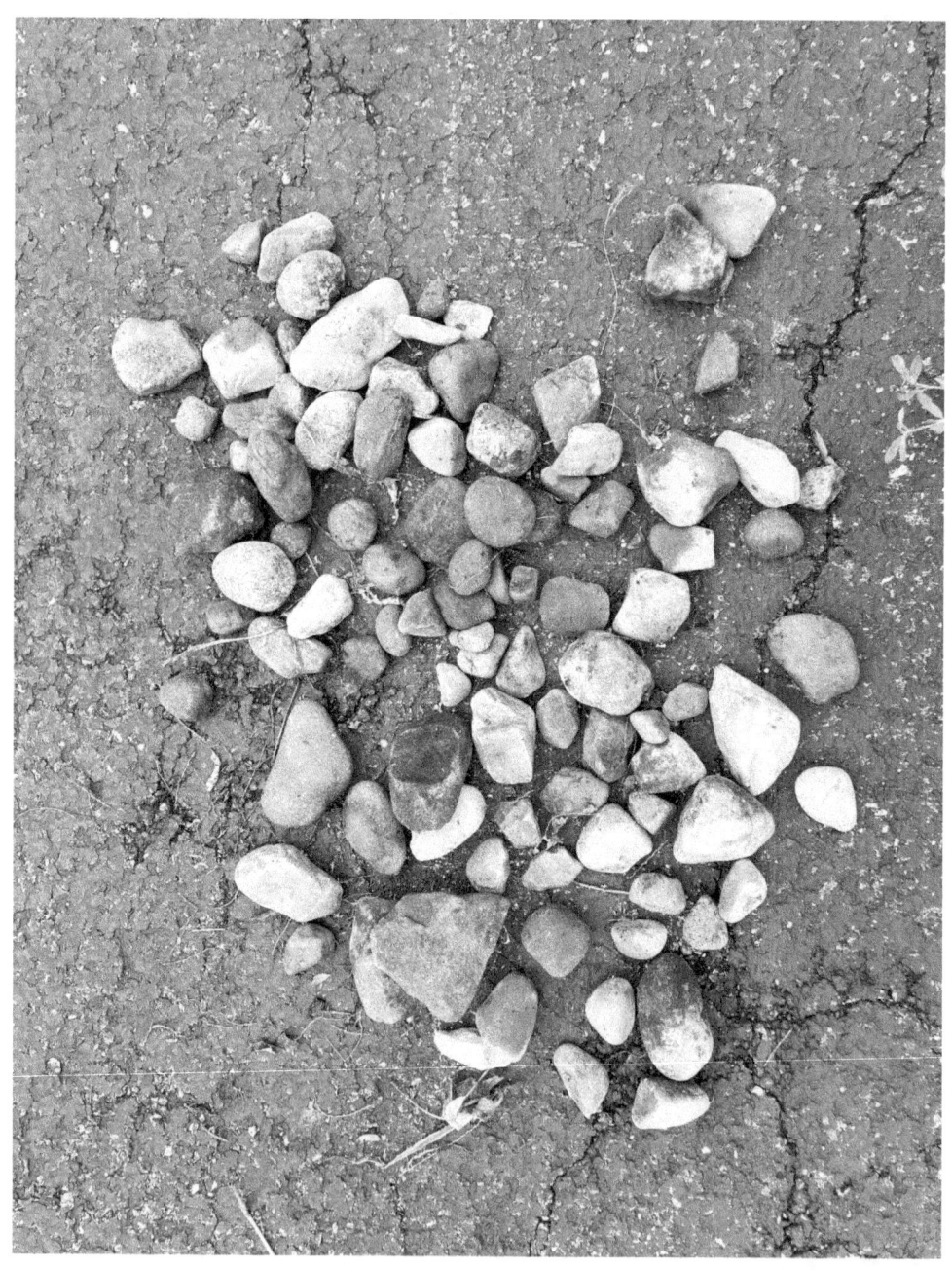

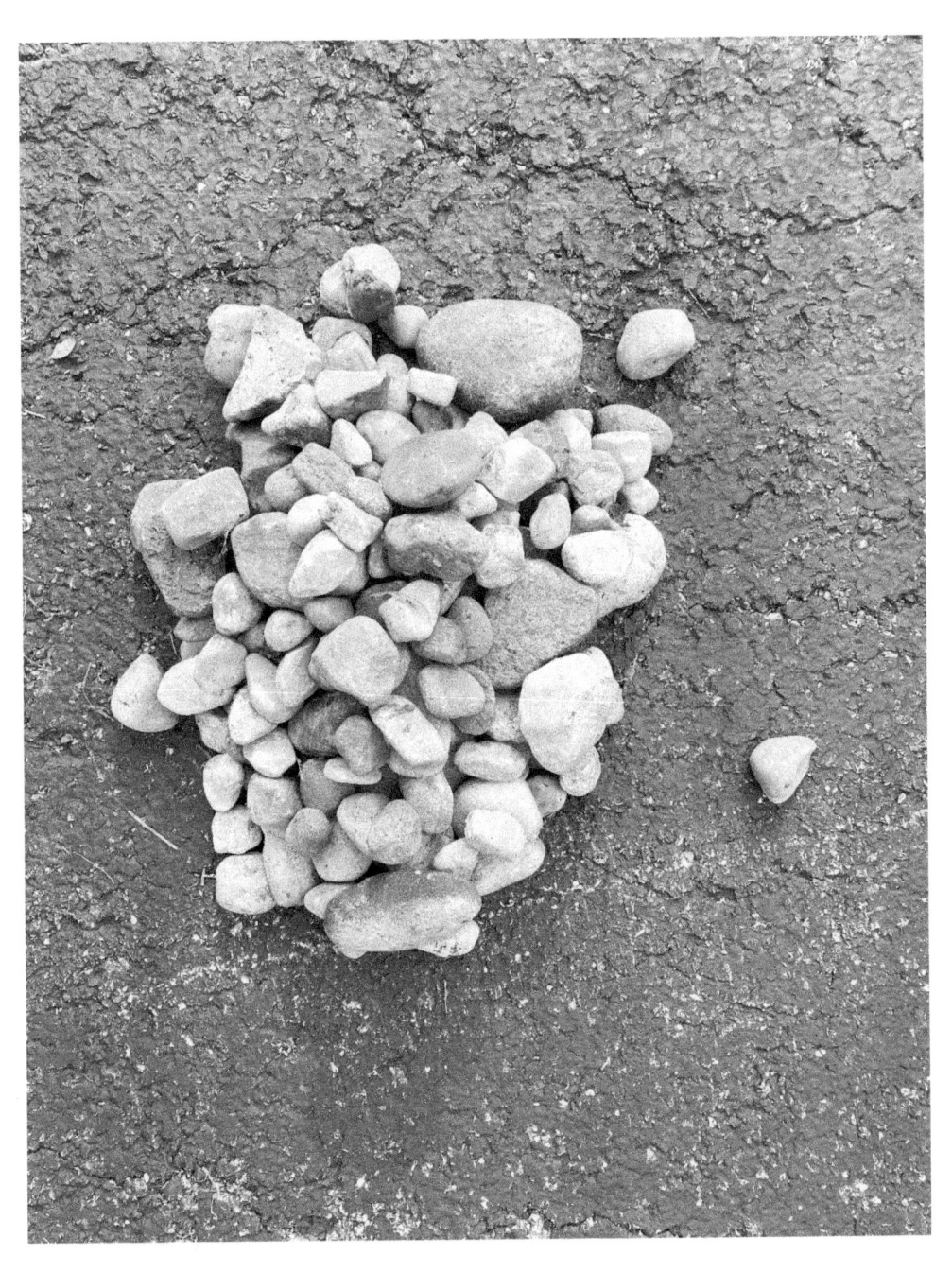

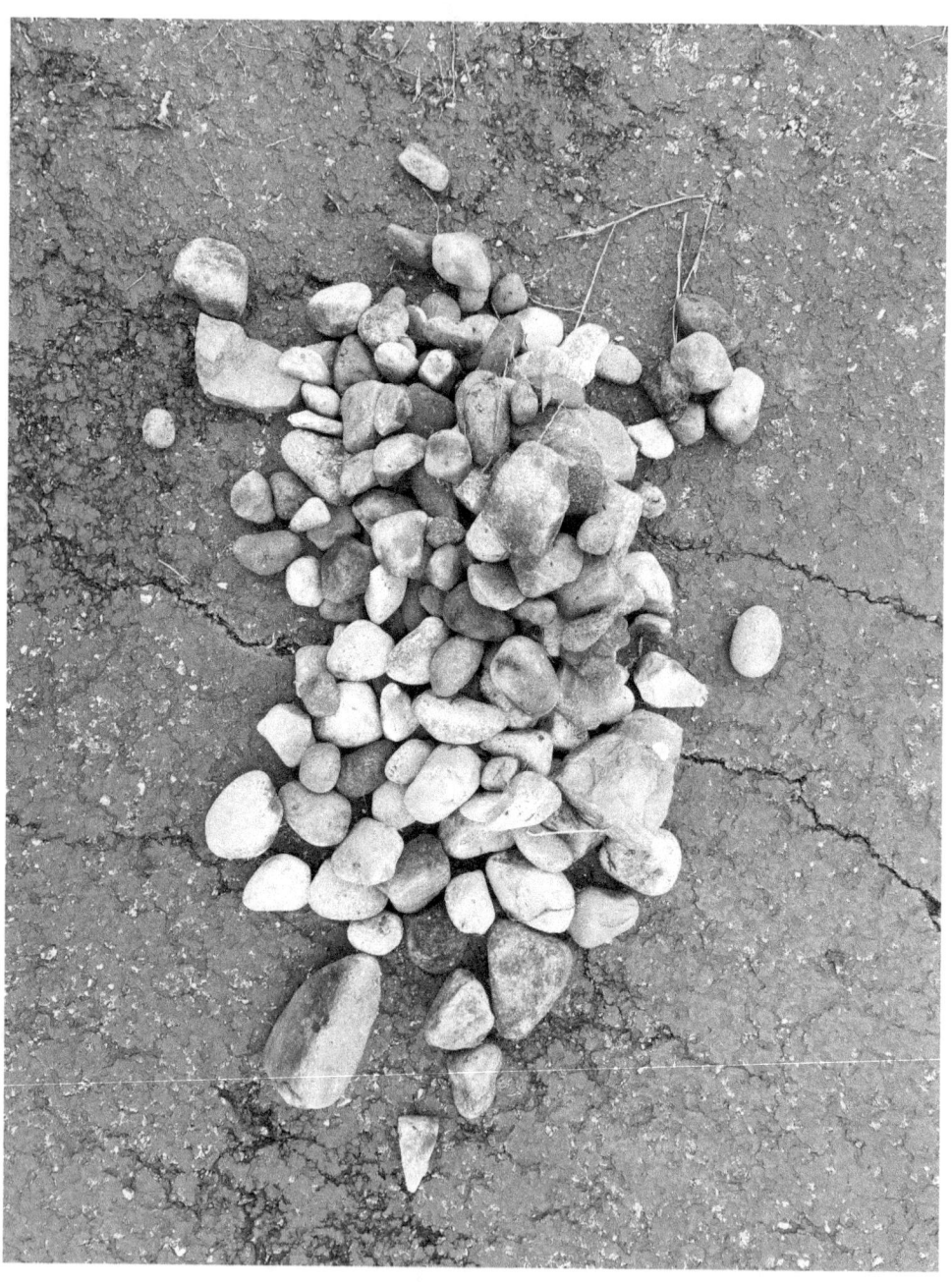

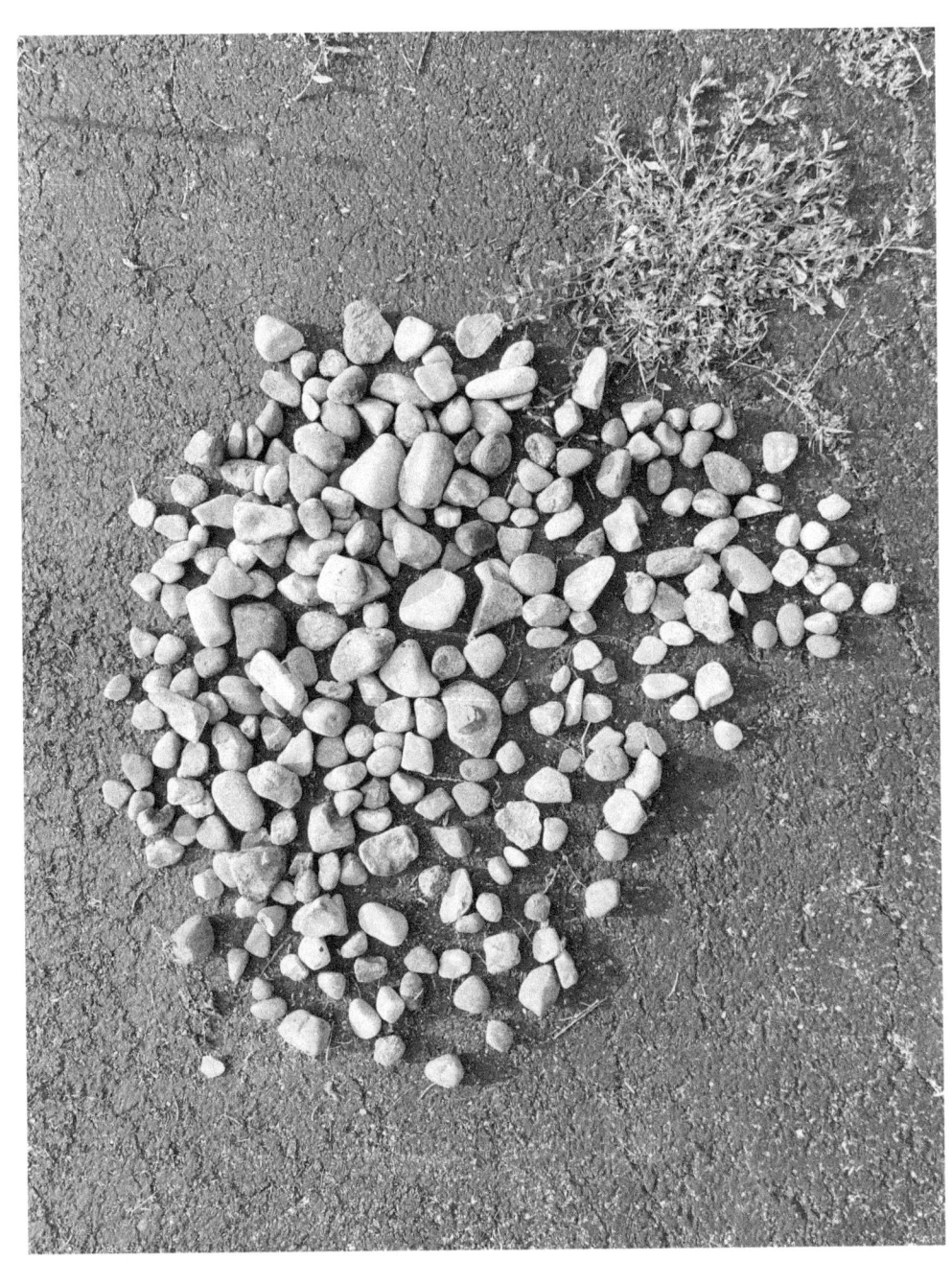

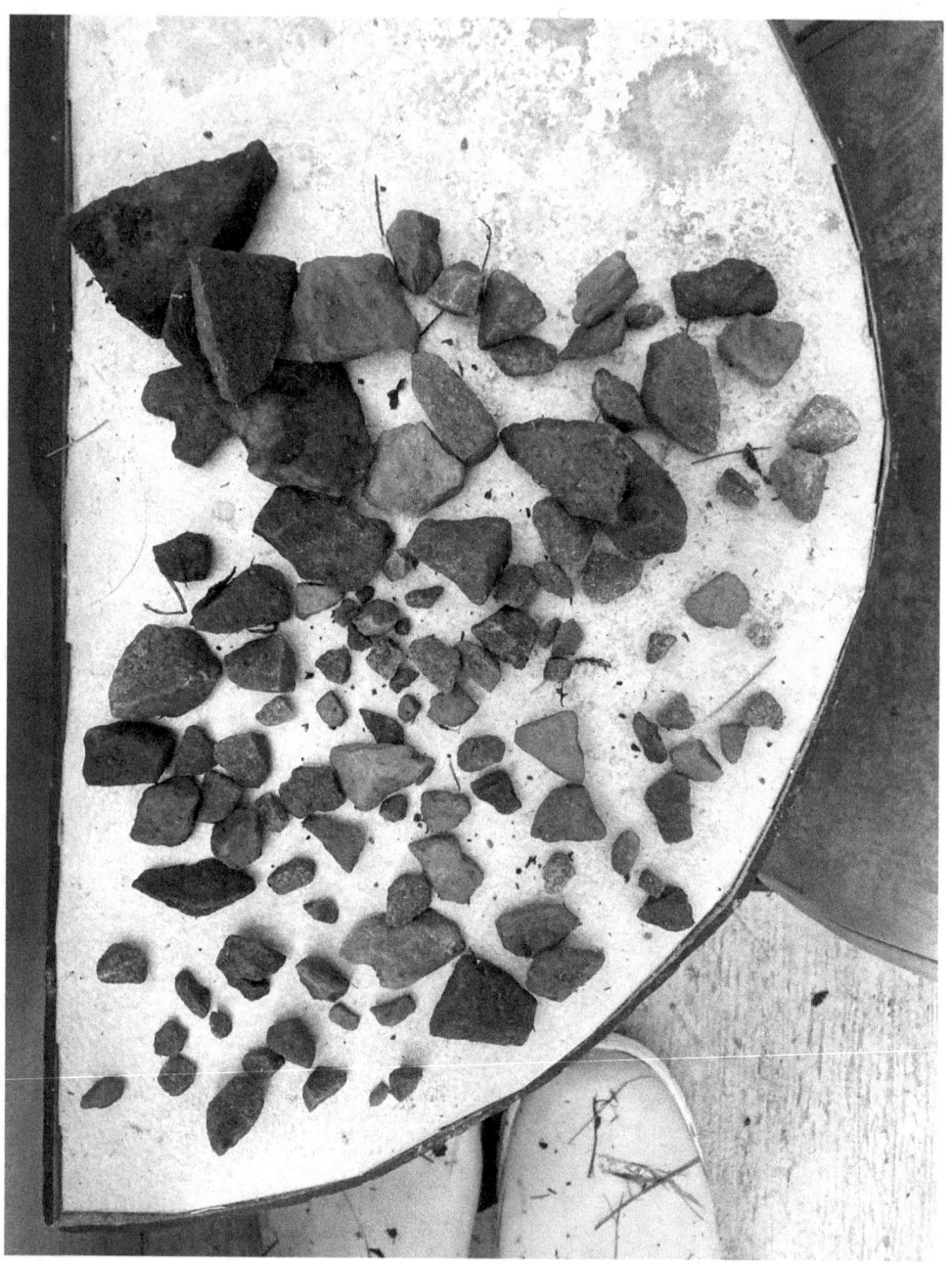

Walk 1: 95 stones
Walk 2: 180 stones
Walk 3: 170 stones
Walk 4: 284 stones
Walk 5: 111 stones

Each walk served as an independent meditation as Erik Satie's *Vexations* led and kept me on a smooth ledge. Never fully settling into a mindset or being in a state of rest during the process encouraged me to be more aware of the relationships between each stone as they were selected. Each one nestled securely in their space, sometimes directly in contact with other stones allowing for the flow of air and water between, and other times isolated in a bed of soil compact and tucked in. Each time a stone was picked up the void left behind had a different charge, one that was longing for its previous occupant but now open to new possibilities.

The process of slowing down while on a walk and looking for stones while listening to music that never settled, yet provided some comfort and rhythm in its repetition was an experience that will be present on every walk I take, whether it is with my dog on a mountain trail or in my home processing a question.

- Rumpelstiltskin Morgan

Untitled

by Sergio Luna
made by Lauren Sudbrink & A. P. Vague

 Digital imaging

From an image reduced to 300 pixels ("The first camera phone photo sent on June 11th, 1997"), each of these pixels is sent in a disorderly way to the maker/collaborator in order to they can recompose the original image according to their criteria from the following information:

1. The image measures 20 pixels wide by 15 high
2. The original image belongs to the photograph of a newborn baby
3. At some point the image has been sent by phone

Several makers/collaborators participate and each one make their own version of the original image. The work is ironic about some issues related to the digital image today, such as the concept of authorship, original/copy or the making of derivative works.

 - Sergio Luna

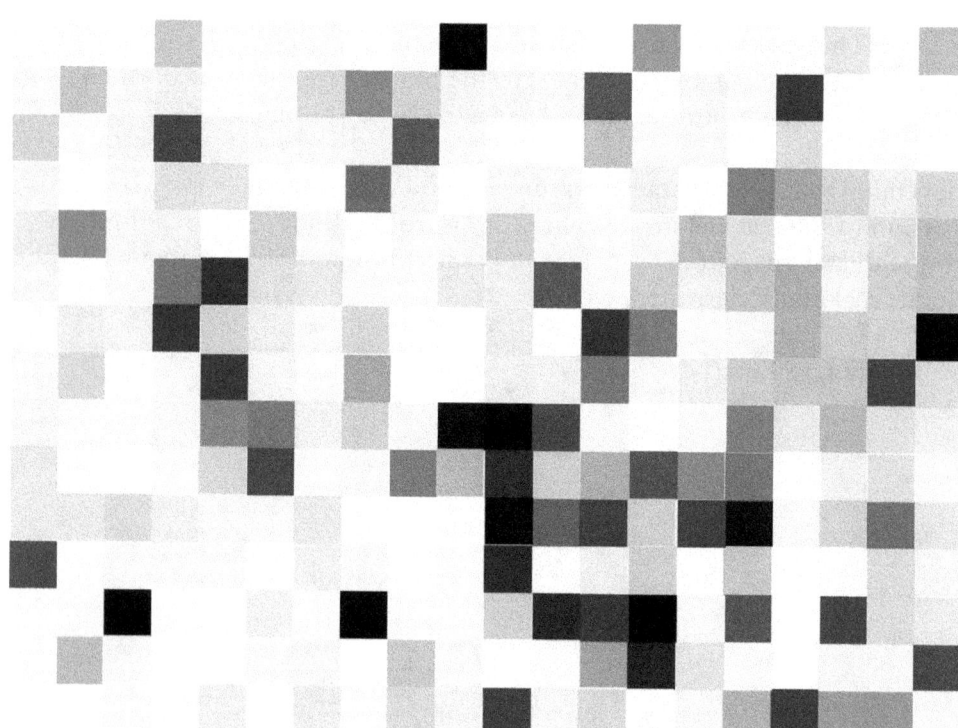

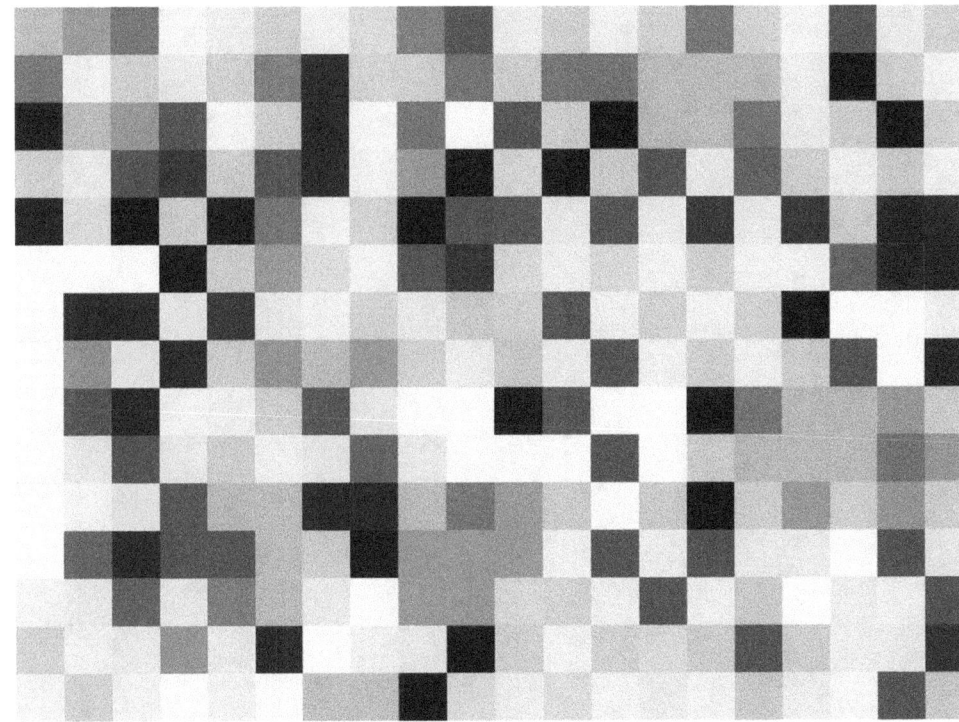

I originally worked on writing a sketch in p5.js in order to randomize the pixels from the original image that Lauren Sudbrink sent to me. After processing the image to prepare it for randomization, it later started to make better sense to complete the piece "by hand" in Photoshop using the paint bucket tool and a 15 x 20 grid layout.

- A. P. Vague

Untitled

by Raymond Yeager
made by Sue Uhlig

 Drawing

This work will recognize the psychosocial consequences and effects of loss from the COVID-19 pandemic. The COVID-19 pandemic is more than a global health crisis. Its psychological effects have upended many conventions of normalcy and certainty in the future. As we cautiously emerge from the pandemic, we find the world has changed. The absence of things that we used to take for granted in our lives is palpable. We all have lost something. Many lost the public and private connections that construct our daily lives; others may have lost a loved one. This work strives to recognize and be a record of this absence. The work begins with the "maker" asking family, friends, and strangers to create a "drawing" of something they lost during the quarantine. It can be an image, story, or simply marks that represent what they lost. The "maker" will then erase the drawing and collect the erased remains in a small glass vial. The paper with the "ghost" of the drawing and the glass vial with the erased remains will be displayed together. Through the process of erasure and collection, this piece will commemorate some of the losses both big and small. After the exhibition, the glass vials will be given to the individual participants as a tangible remembrance of things that they have lost.

 - Raymond Yeager

Instructions:

1. The At A Distance maker will ask a friend/family member/stranger to write or draw on a 11" x14" bristol paper something they lost during the pandemic. The "drawing" can be an image, story, or simply marks that represent what they lost.
2. The maker will take the drawing and erase it. Then carefully collect the eraser remains. Keep the paper to display with vial. Title each in a way that seems appropriate.
3. Seal the eraser remains in a glass vial.
4. Display the erased papers with the corresponding vials in a grid or single straight line on a wall. Other display options can be discussed.
5. At the end of the exhibition, the vials and a note of thanks are given to the individuals who participated.

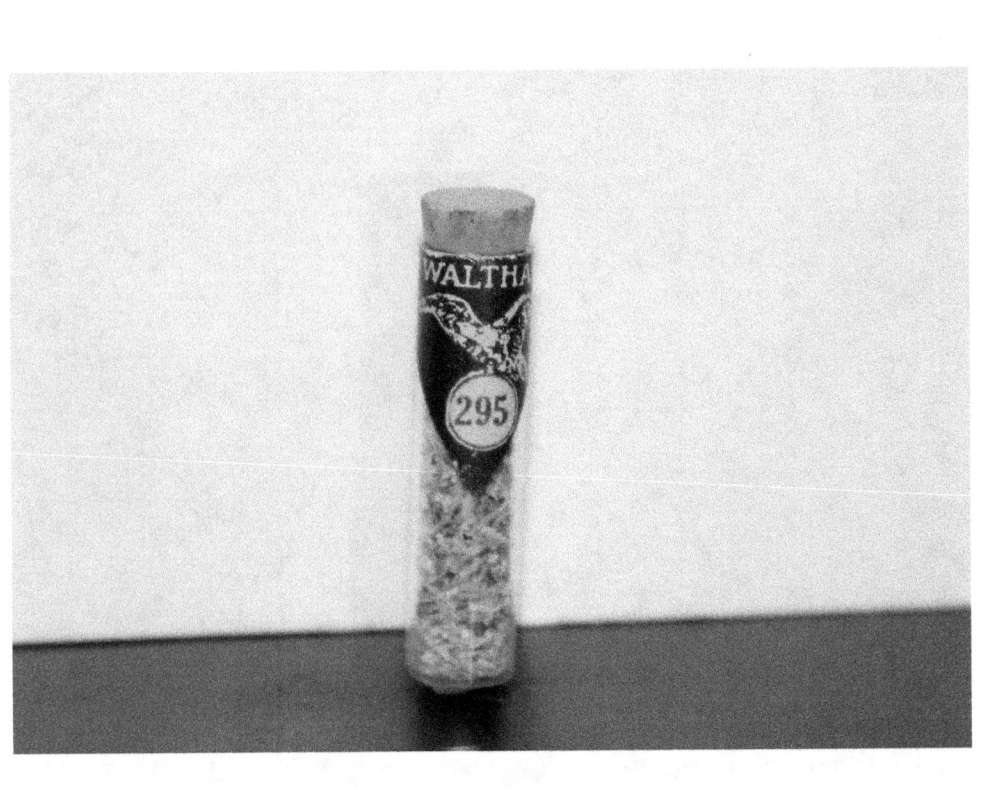

Life

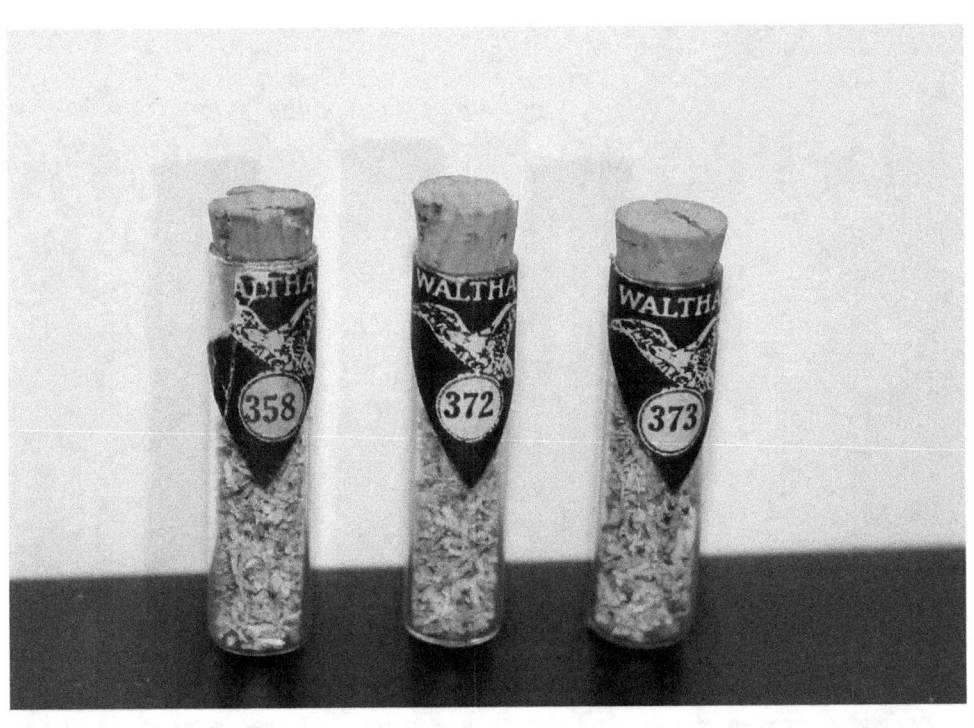

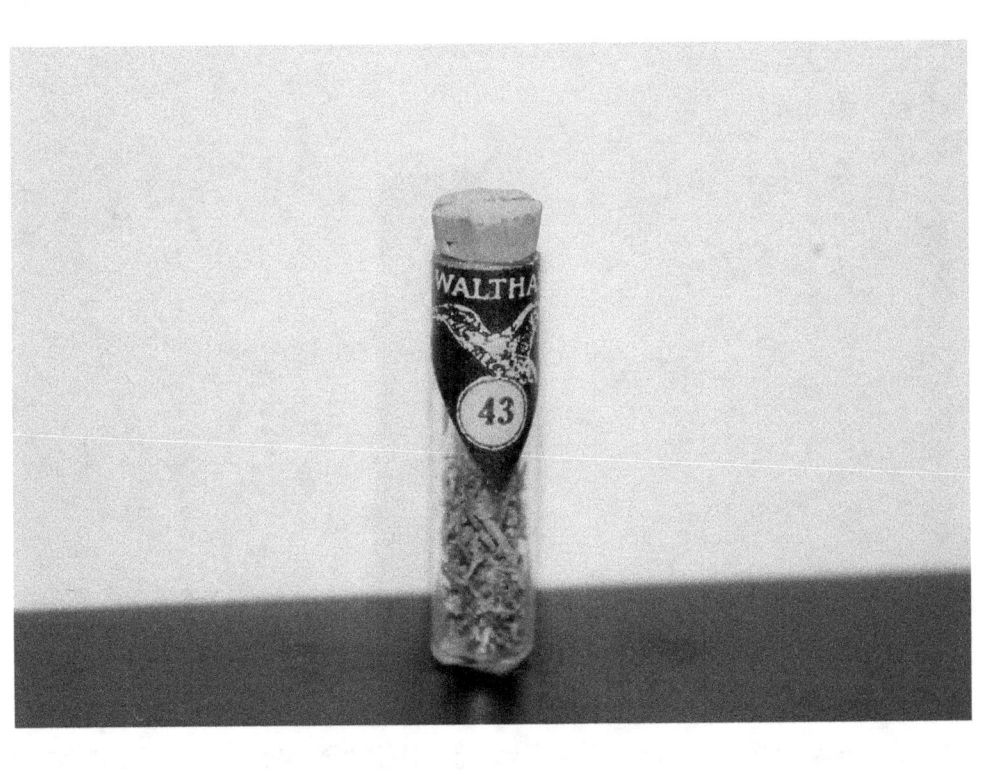

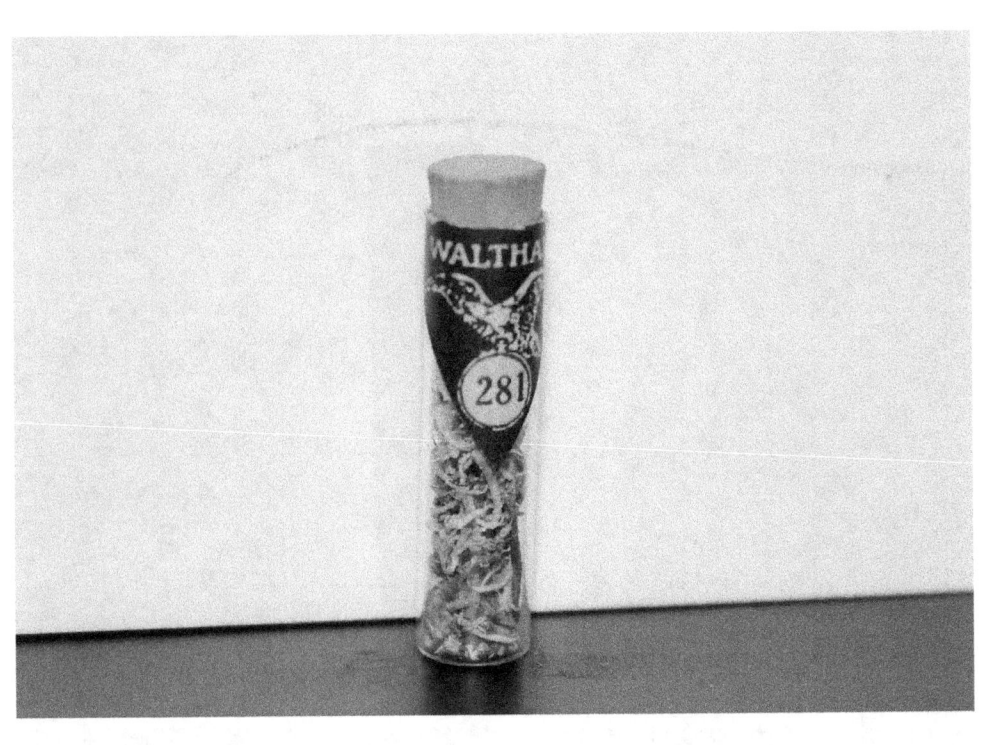

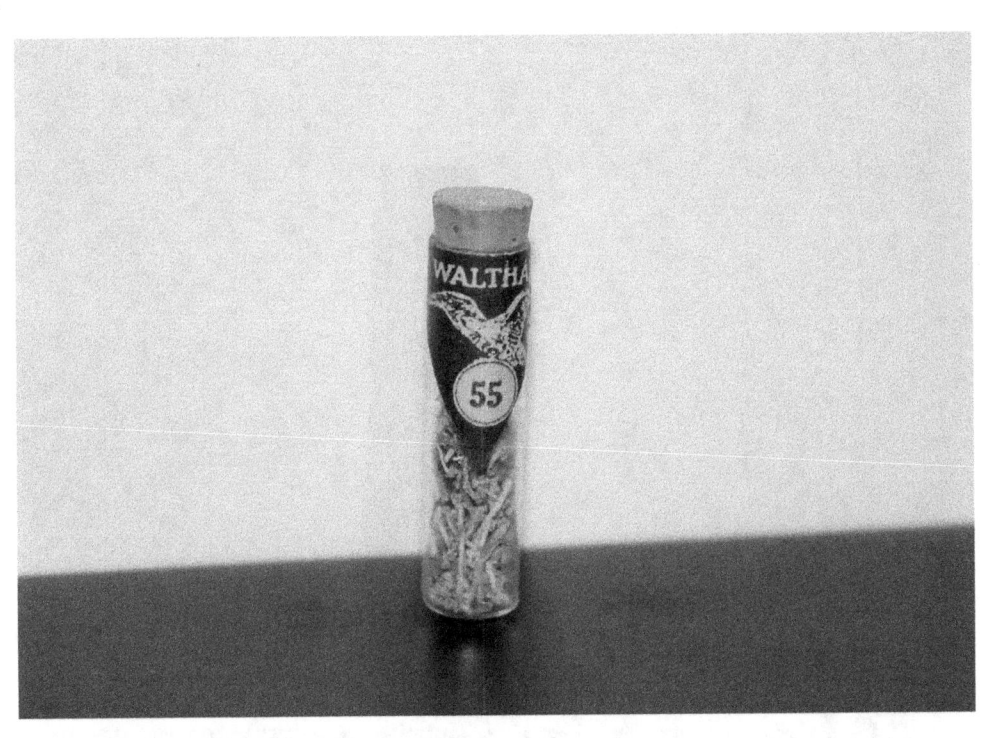

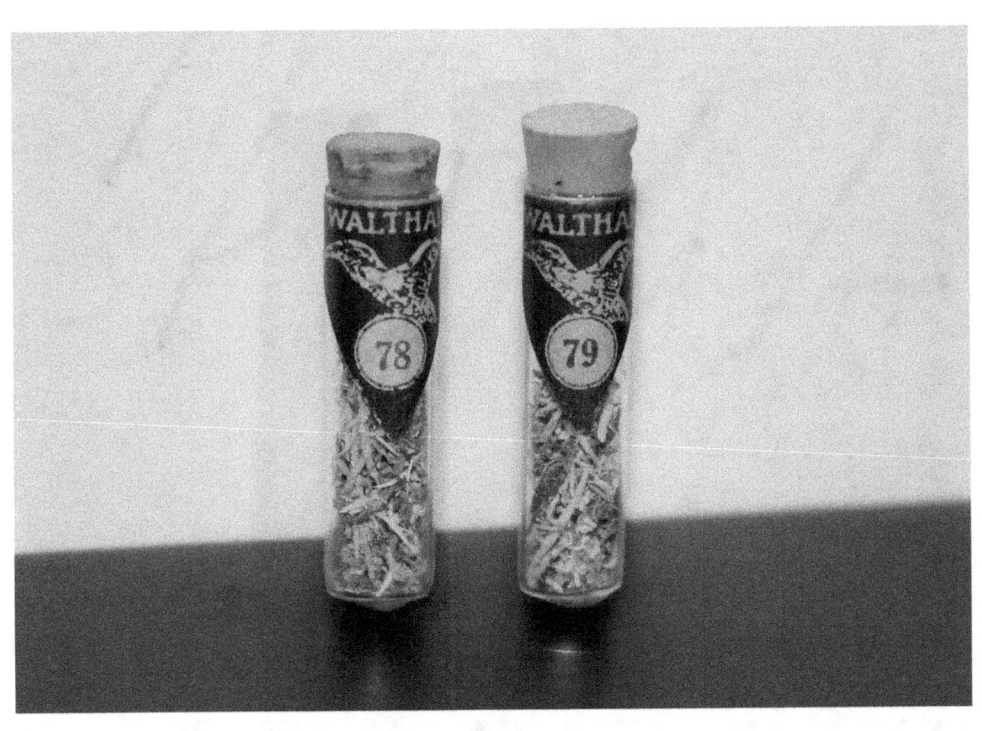

Connection

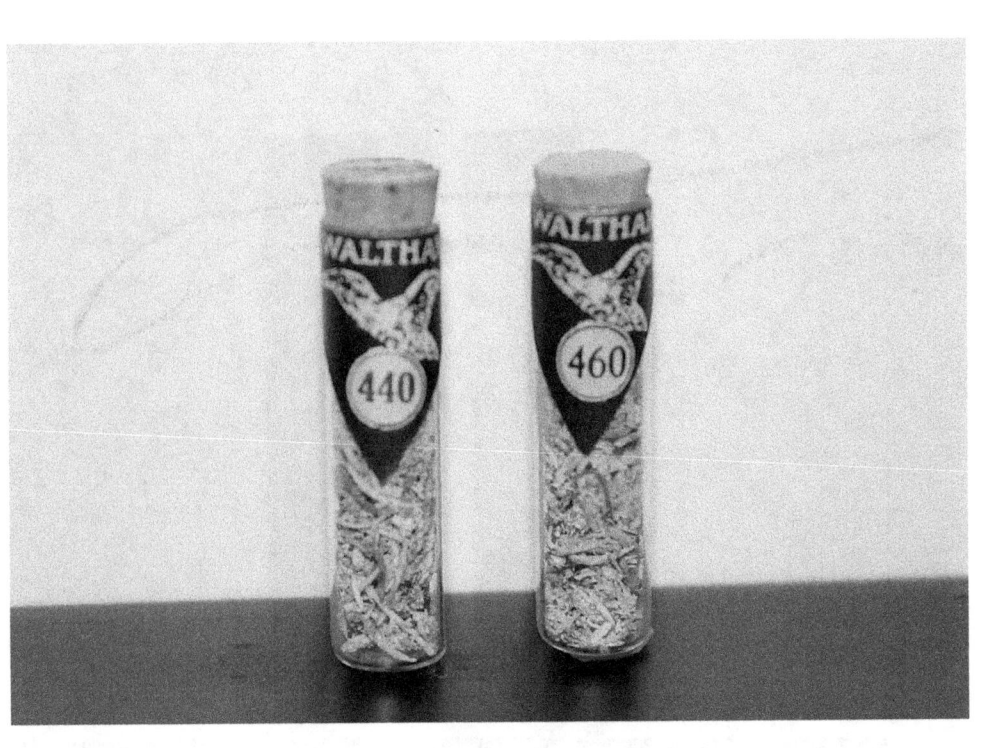

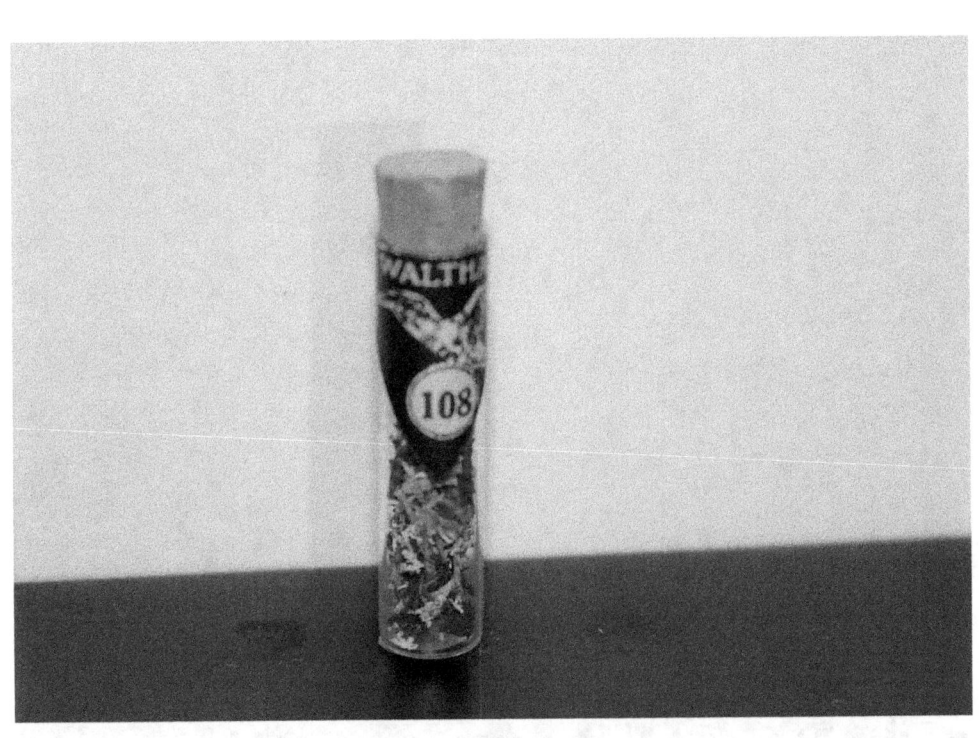

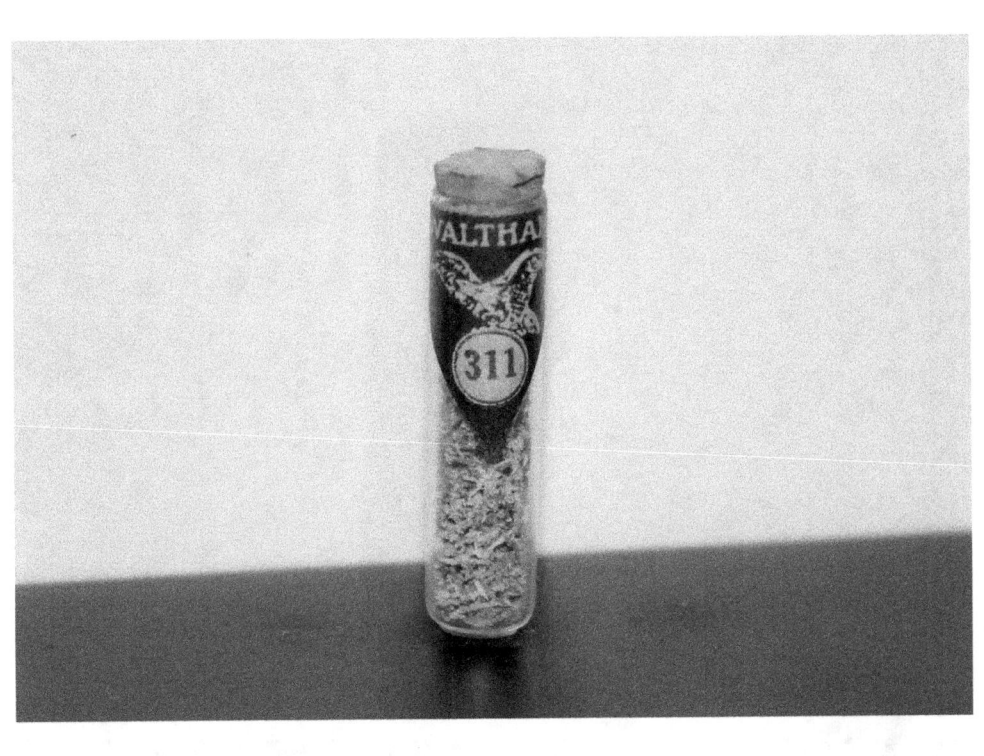

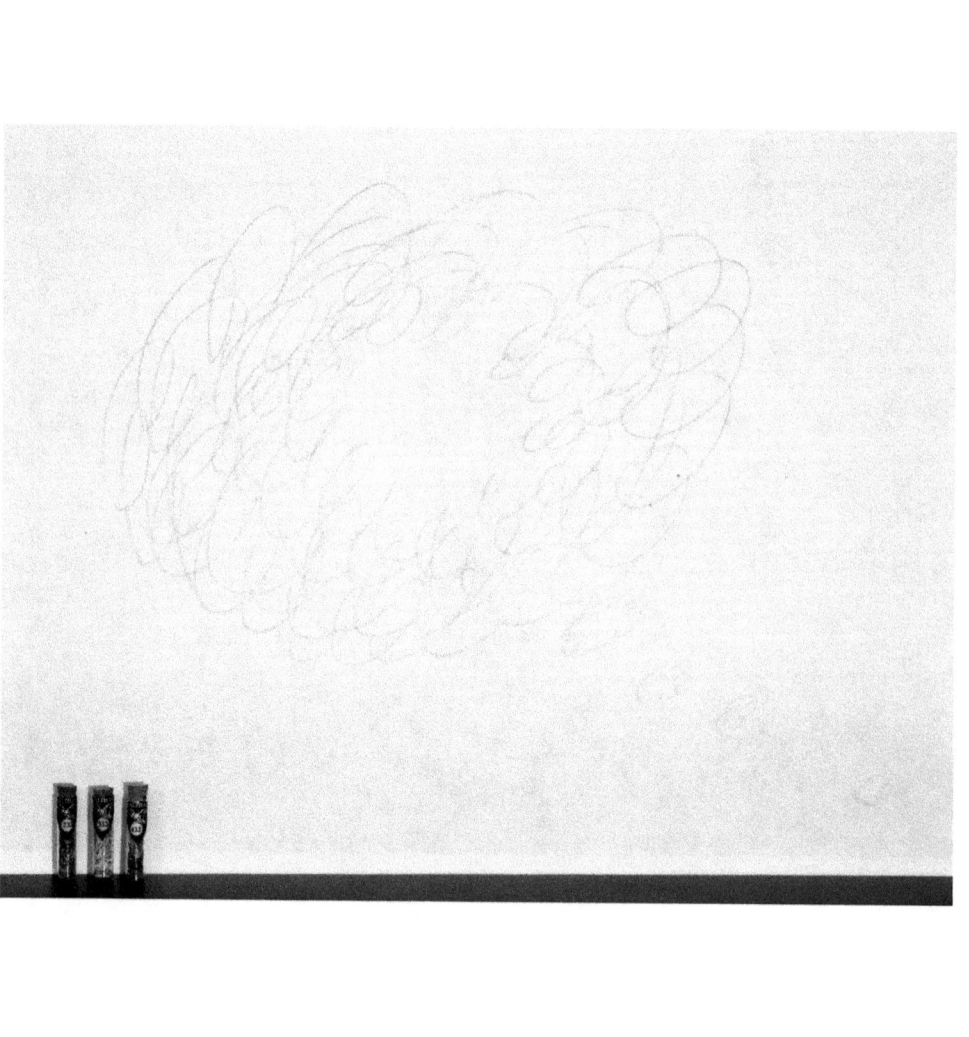

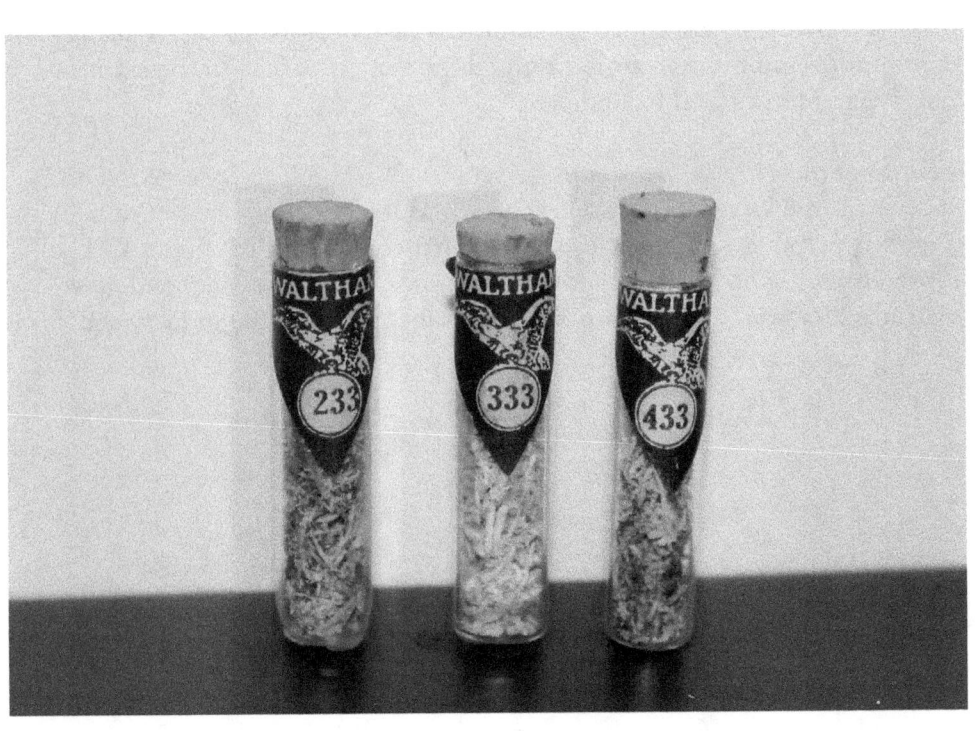

As a maker, Raymond Yeager's proposal of an erased drawing intrigued me due to its historical precedent, how it addressed loss during the pandemic, the value placed on what is considered trash, and the expansion of the role of maker to include a more diverse group of participants.

After 17 long months of not seeing family during the pandemic, I got vaccinated and made the trek from central Pennsylvania to suburban Chicago to see them in the summer of 2021. Who better to ask to participate in this project than those whose company I lost during the pandemic? At two different gatherings on June 5, I asked family and friends of family if they would be interested in drawing/writing/storying what they lost during the pandemic. I provided an assortment of materials, and they provided responses that spoke of loss of time, loved ones, social life, community, and mind. Another flipped the notion of loss to focus on positive outcomes of the pandemic.

In erasing their losses, I empathized with each struggle, or rejoiced in each success. Some losses were easy to erase, and the ghost marks that remained were wispy traces. Other losses were almost etched into the paper and left a more visible, lasting mark. I gathered the eraser bits in secondhand glass vials used for watch parts, thus further conceptualizing the reduction of time.

- Sue Uhlig

Instruction Art Quilt

by Alanna Stapleton
made by Gregoria Vryttia

 Quilting

In times of uncertainty and change, it can be difficult to analyze and process. You might not know exactly what to say or how to feel. As an illustrator, I use illustration as a means for communication, so I draw when I have something to say. My illustrative work is more outward facing, something that is shared and meant to live in the world.

Quilting doesn't occupy the same space for me. I still feel the need to make when I don't have any words or explanations, and I can make an improv quilt thinking only about color and shape and balance. It becomes a meditative process for me, grounding me in my body and helping me to access what I'm really thinking and feeling.

As the world around me went into lockdown in early March 2020, I turned to quilting to keep my anxiety in check. I don't tend to use quilt patterns, preferring to make it up as I go along, but I made several quilts at the beginning of my time in quarantine following quilt patterns. Having specific instructions to follow was really satisfying and calming when I didn't have any control over what was happening outside my apartment.

I was inspired by instruction art and quilter Heidi Parkes' Scavenger Hunt Quilts. I wanted to write a pattern that acted as both a guided meditation and instructions for making a quilt. I hope to prompt makers to think more deeply about the mundane and to use making as a meditative process.

Instructions:

To begin, set some parameters for yourself. Think of structure not as a limitation but as a framework play inside. And, since you're the one making the rules, remember that you can also break them whenever you want.

Materials:
Try to use materials you already own, adjusting your planned color palette as needed. Cotton fabric is good for quilting, but don't limit yourself to just sewing pieces of fabric together.

Color:
Find a favorite photo that brings back a happy memory. Pick one color from this photo to build your color palette around. Determine no more than 6 other colors to be a part of a limited palette. Making these simple decisions at the beginning helps make each of your design decisions that much easier.

Create 1 quilt block per prompt. Not all blocks need to be the same size. Try not to think about how they'll fit together until the end.

Rhythm/Sound
What kind of noises are a part of your daily life? Is it an album you've been playing over and over? Is it your kid crying or laughing? Is it the cadence of a podcast host's voice? Is it your partner's "work voice"? Is it construction outside your window? Find a way to visualize that noise.

Movement
Consider what kinds of movement are a part of your day-to-day life. If possible, go for a walk. Why did you take this particular route? Think about the concept of a labyrinth. Create this square based on how your body moves.

Tatse
What are you hungry for? Think about a word that describes how that food tastes: bright, tangy, hearty, cheesy, sour, sweet, salty, nutty, crunchy, etc. Make a quilt block that embodies the word you've chosen based on your appetite.

Humor
What makes you laugh? Play a favorite funny movie or comedy special while you make this quilt block.

Time
Chaos changes our perception of time. Check the clock - what time is it? Set a timer for 30 minutes. Design and make your time-themed block within that 30 minutes.

Touch
Pick an object that you touch every single day. Trace the silhouette of that object. Use that shape to design your touch-themed block.

Connection
Get in touch with a friend. Call them, video chat, or write them a letter. Use memories of your relationship to inspire this block.

Place
You've probably been spending a lot of time at home because of the pandemic. What do you like about your space? If cabin fever is really getting to you, what place have been dreaming about? Design and make this block based on the role space and place play in your life right now.

Assembly:
Now that you've made 8 quilt blocks, it's time to think about how to put them together. Think about visual balance, but also consider the meaning behind each of the blocks. Does it make narrative sense for two of the blocks to be close together, or maybe far apart? Try as many configurations as you need.

You can return to this pattern again and again and always end up with a unique result. The instructions are adaptable and allow for reflection and meditation. Share your quilts on Instagram with the hashtag #instructionartquilt.

- Alanna Stapleton

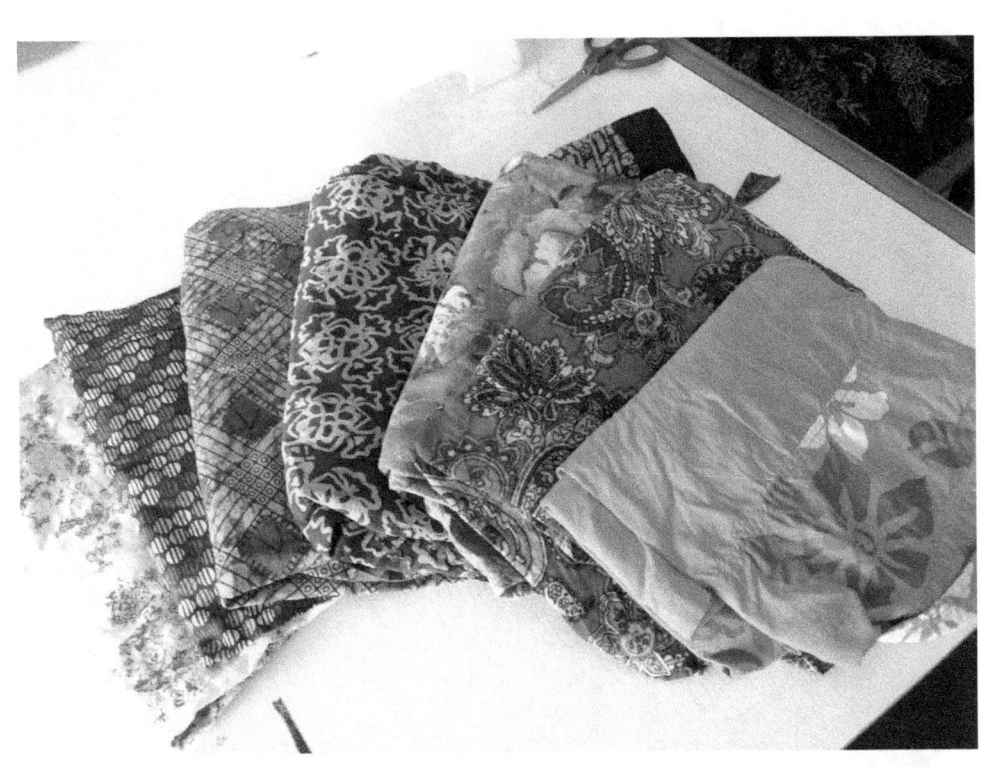

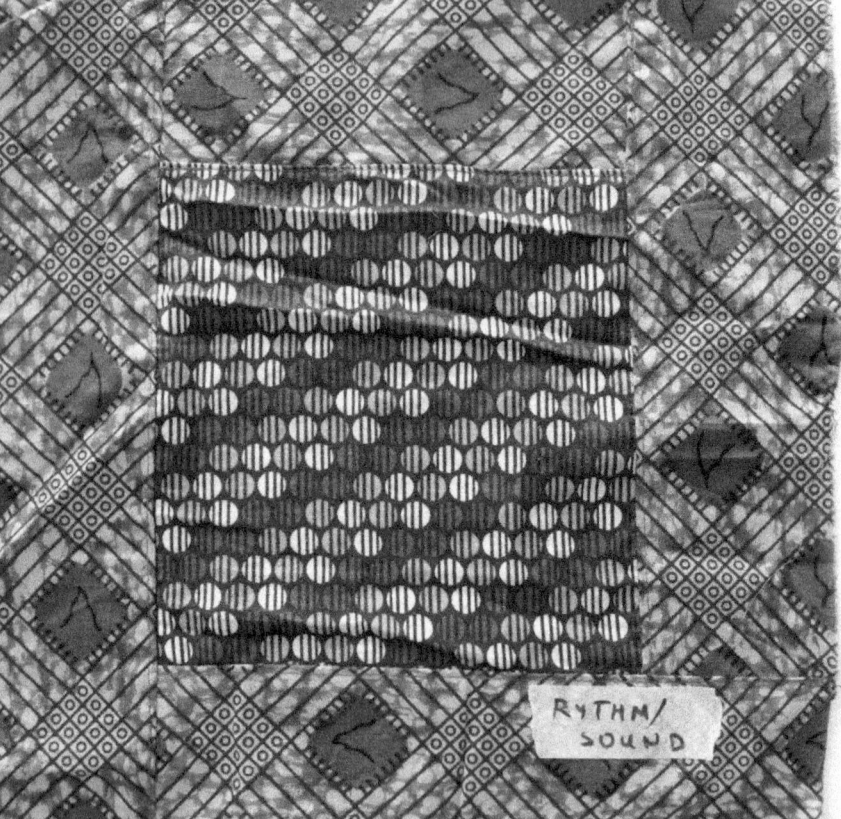

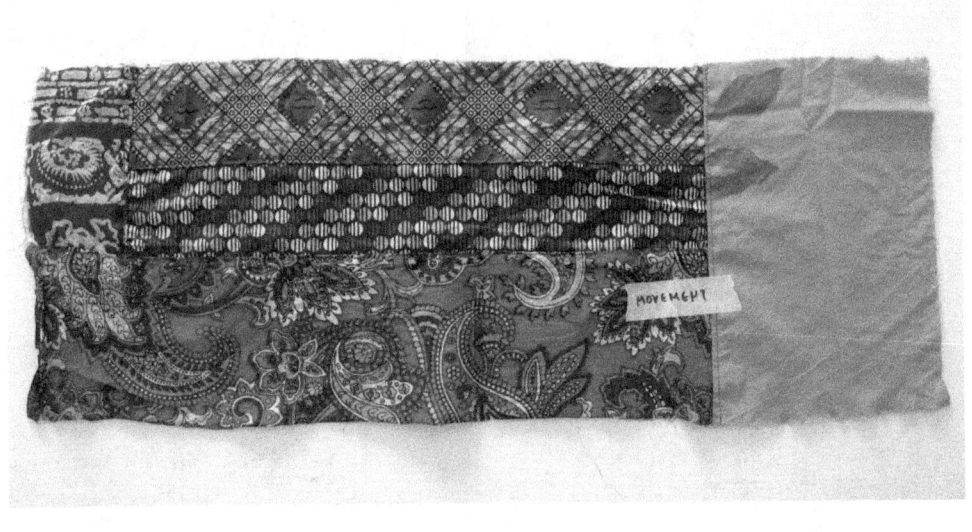

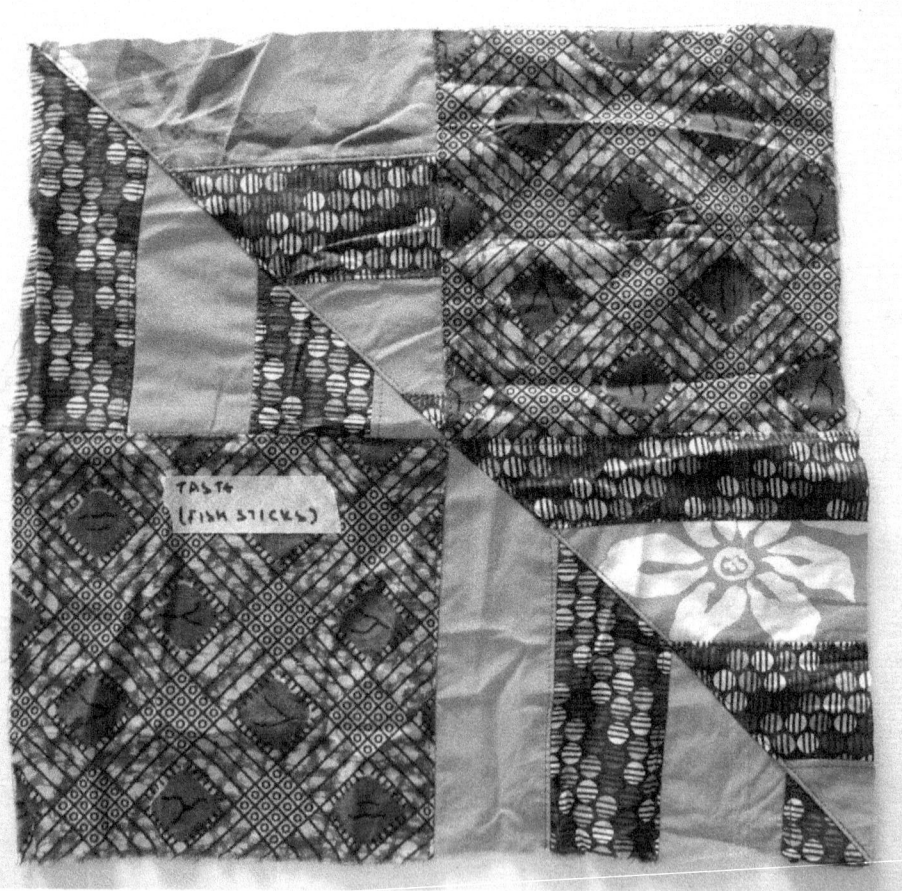

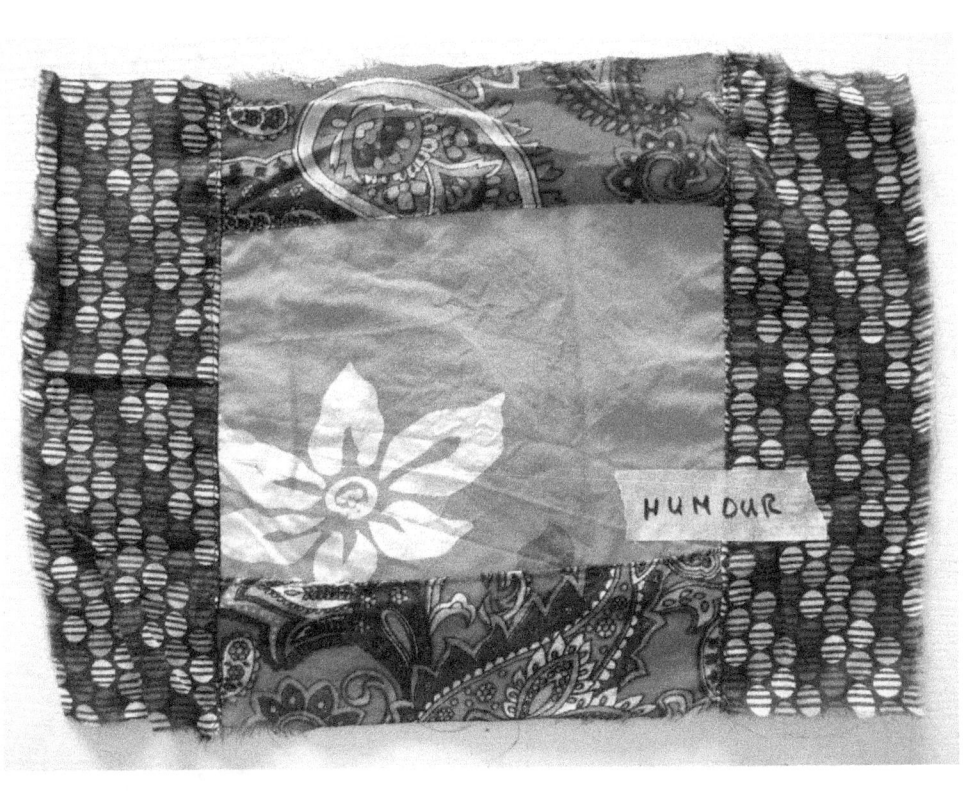

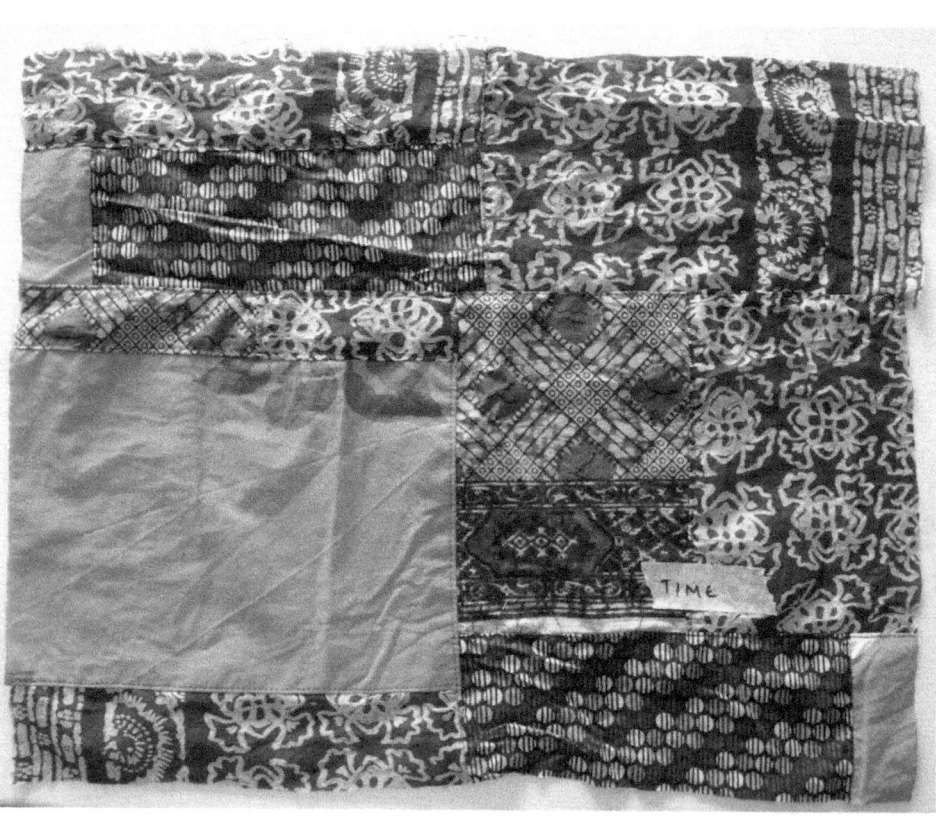

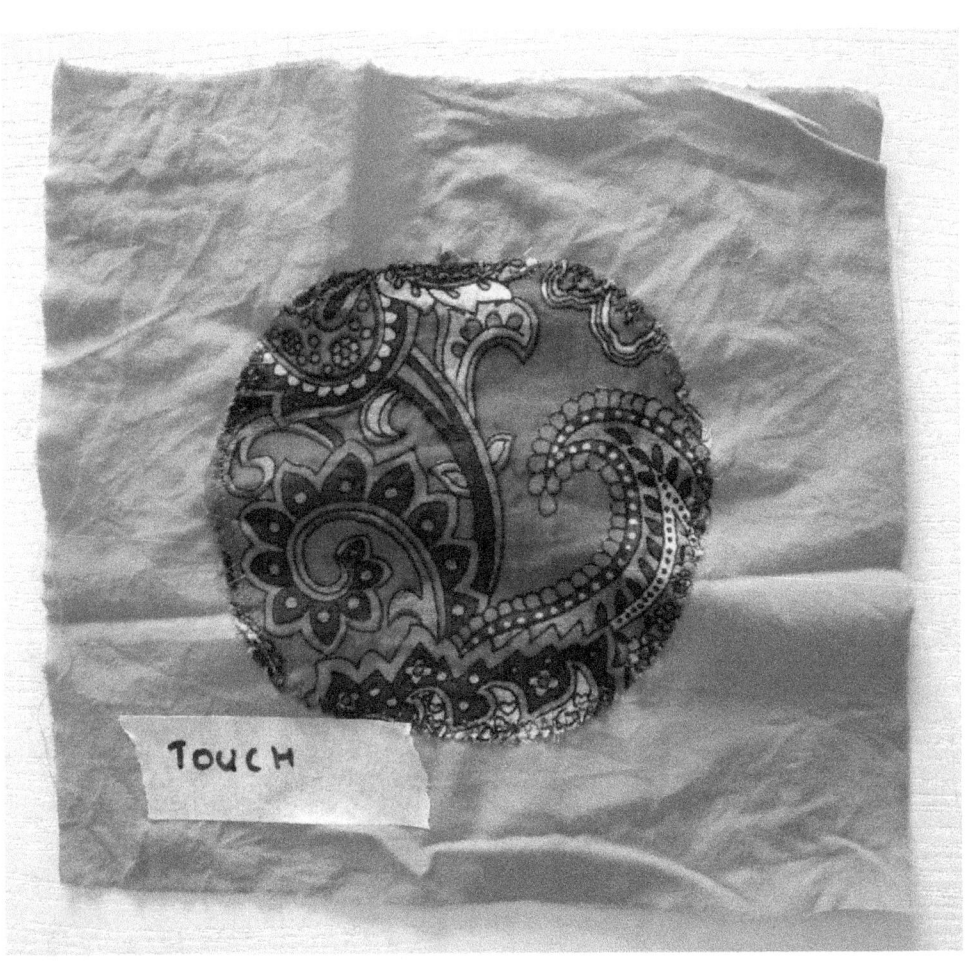

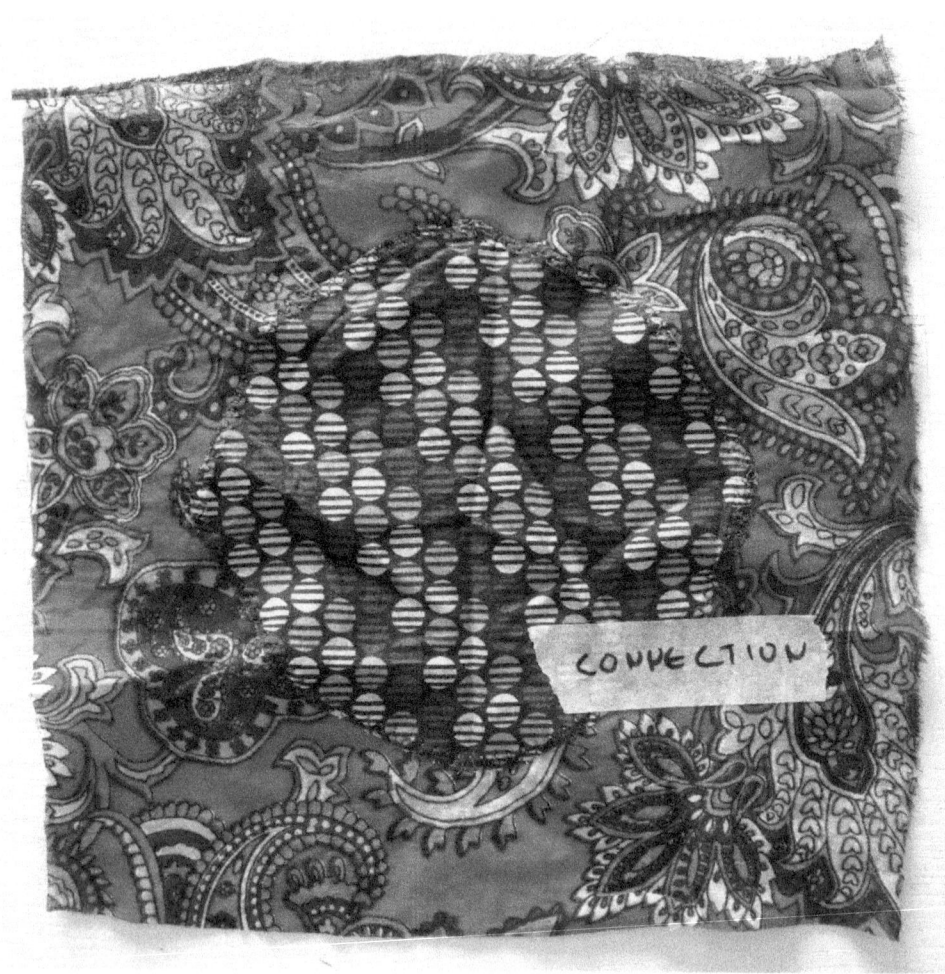

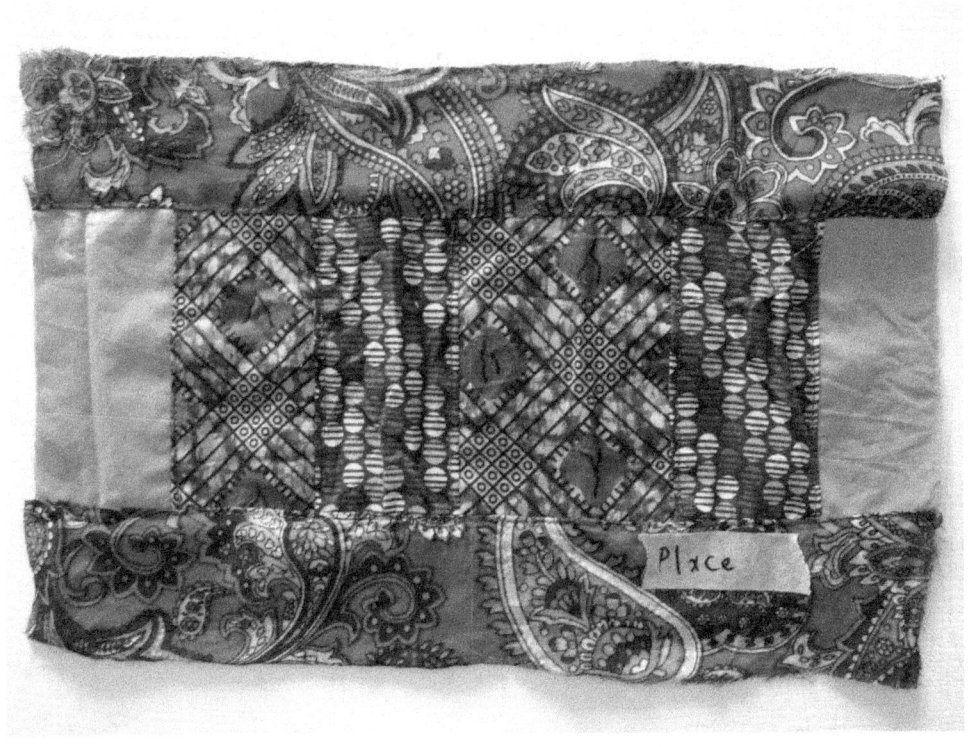

Patchwork and quilting are practices that are not indigenous in Greece, but they have been gaining exposure in the recent years. As an interdisciplinary artist whose main medium is fabric, I have been greatly influenced by them.

My traditional training is that of a sculptress. I focus on non-linguistic communication and I often include my body in my work.

Therefor I was very glad to realize a work inspired by the fellow artist Alanna Stapleton with whom, judging by the instructions sent, we have quite a lot in common.

After asking for her permission I altered the idea a little bit and instead of having a photography as a starting point, I linked the project to the idea of memory by using old clothes of mine as the source of fabric for this quilt.

As the instructions were more like a description of the mind set while making each block and less of the traditional kind, I enjoyed the freedom of it very much.

The final piece is big enough to cover me and I decided to use it instead of framing it.

- Grigoria Vryttia

Googled Earth

by Patrick Lichty & Negin Ehstebian
made by Loraine Wible & Mohan Pillai

 Video

Contact someone from a country you have never been to (or them to yours) and crate a travelogue using Google Street View. Share these, make a book, video or website with the other person explaining the captures of the first person. This creates two pieces.

- Patrick Lichty & Negin Ehstebian

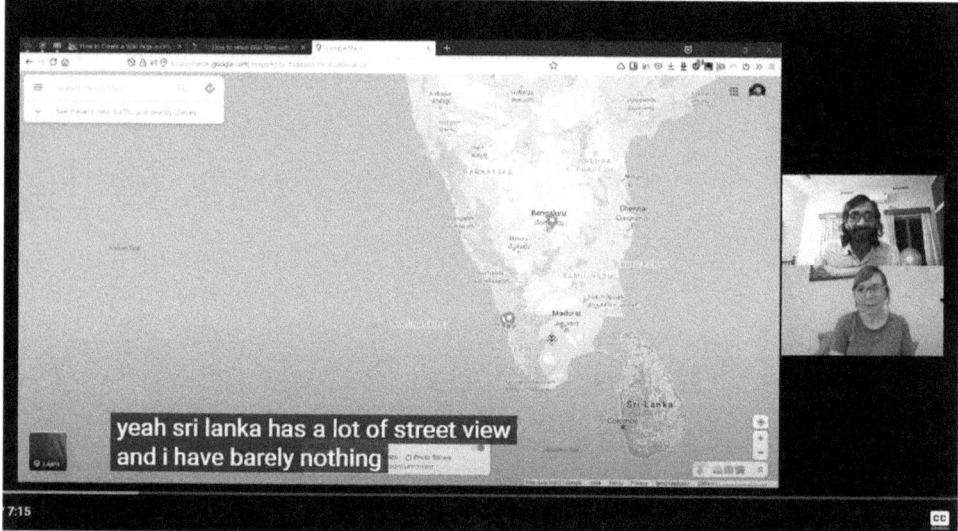

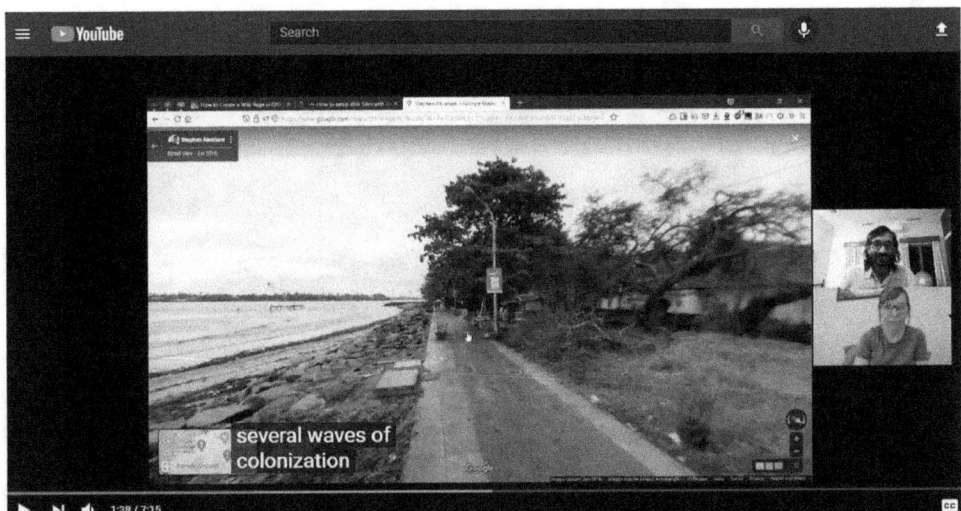

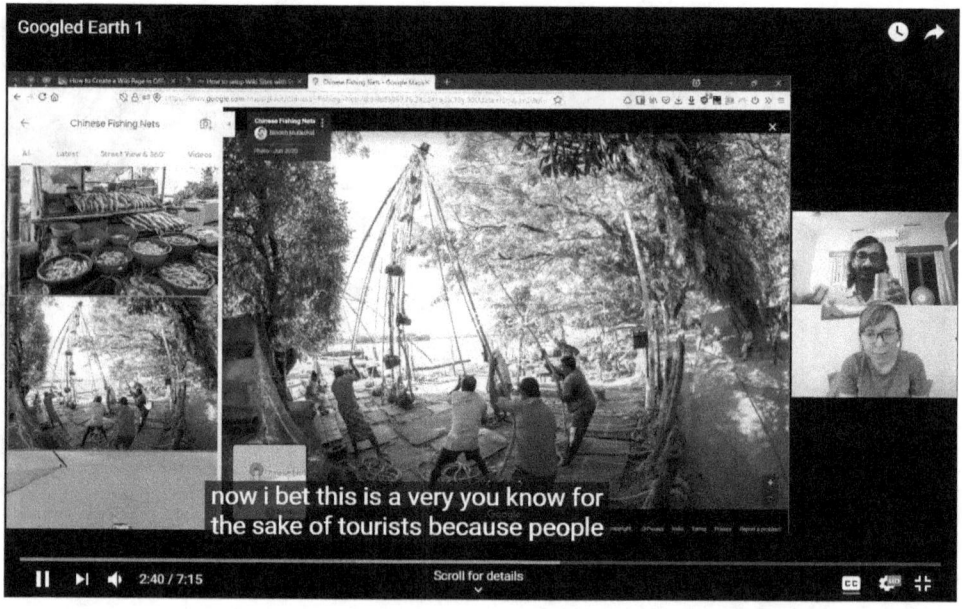

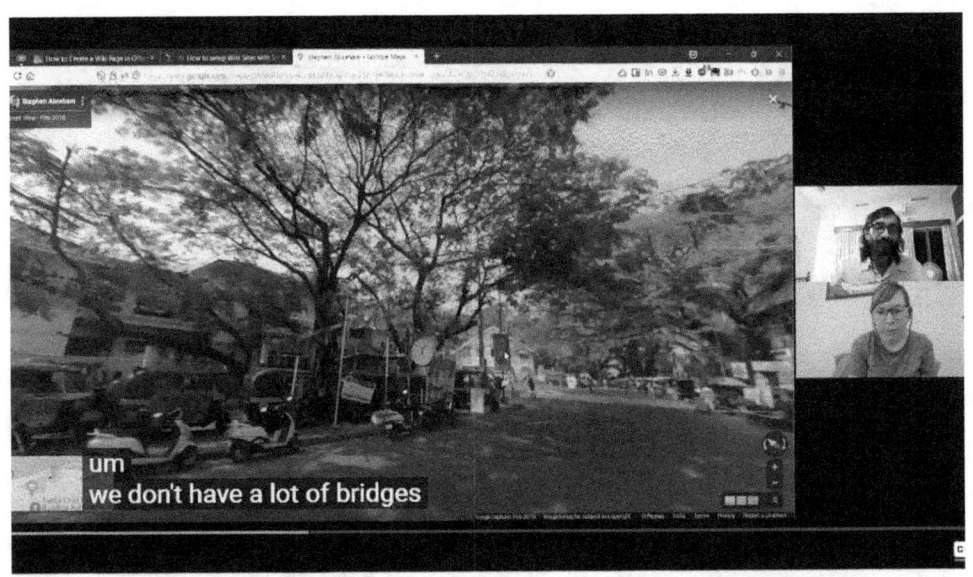

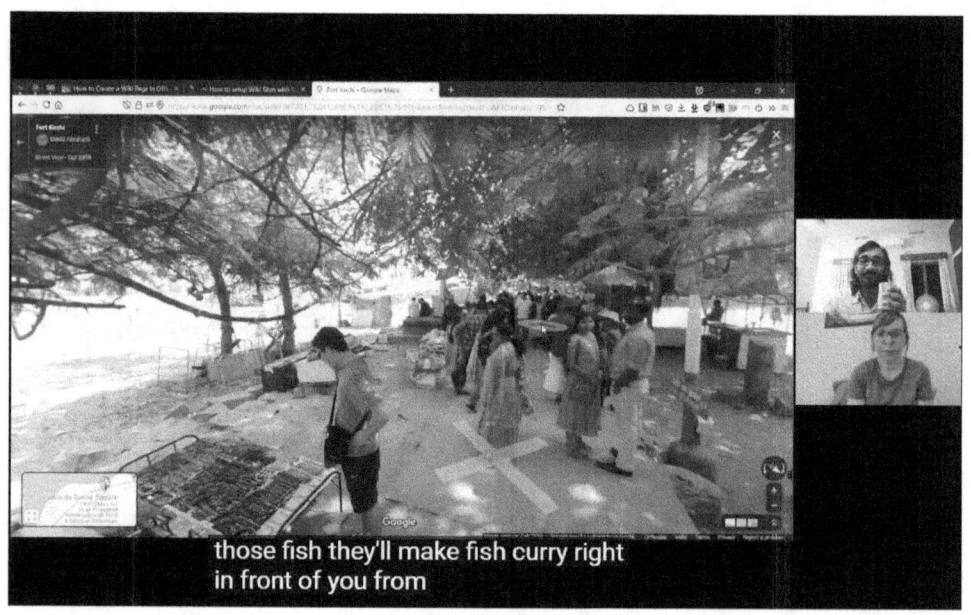

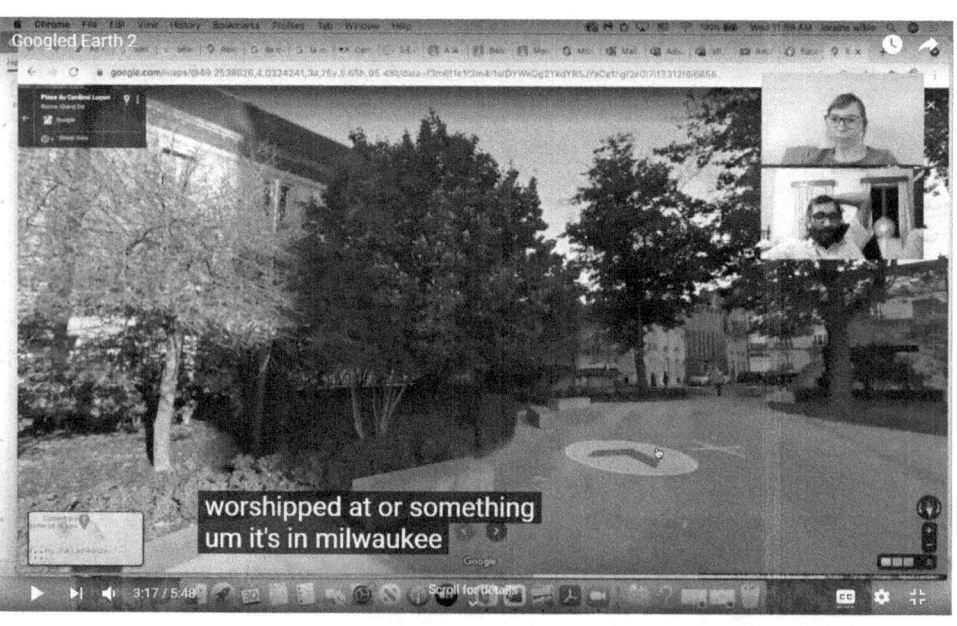

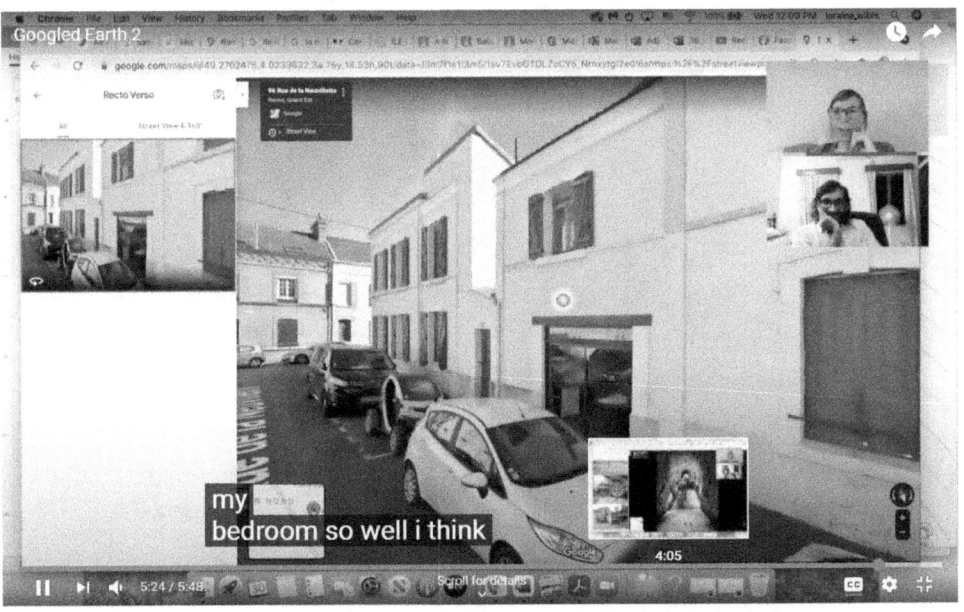

Gestural Landscape Performance

by Patricia Brace
made by Aishling Muller

 Performance, photography

For this piece, the maker will take a series of photographs depicting a "gestural landscape performance." These images are made by dancing or moving in exaggerated poses (like in a gesture drawing) while in nature. This could be in the woods, on the beach, or in another location where buildings are not visible. The photos should be taken from a distance so that the maker's entire body is visible. The maker should wear a plain, all white outfit. This process should be repeated every day in the month of May 2021, resulting in 31 individual photos.

 - Patricia Brace

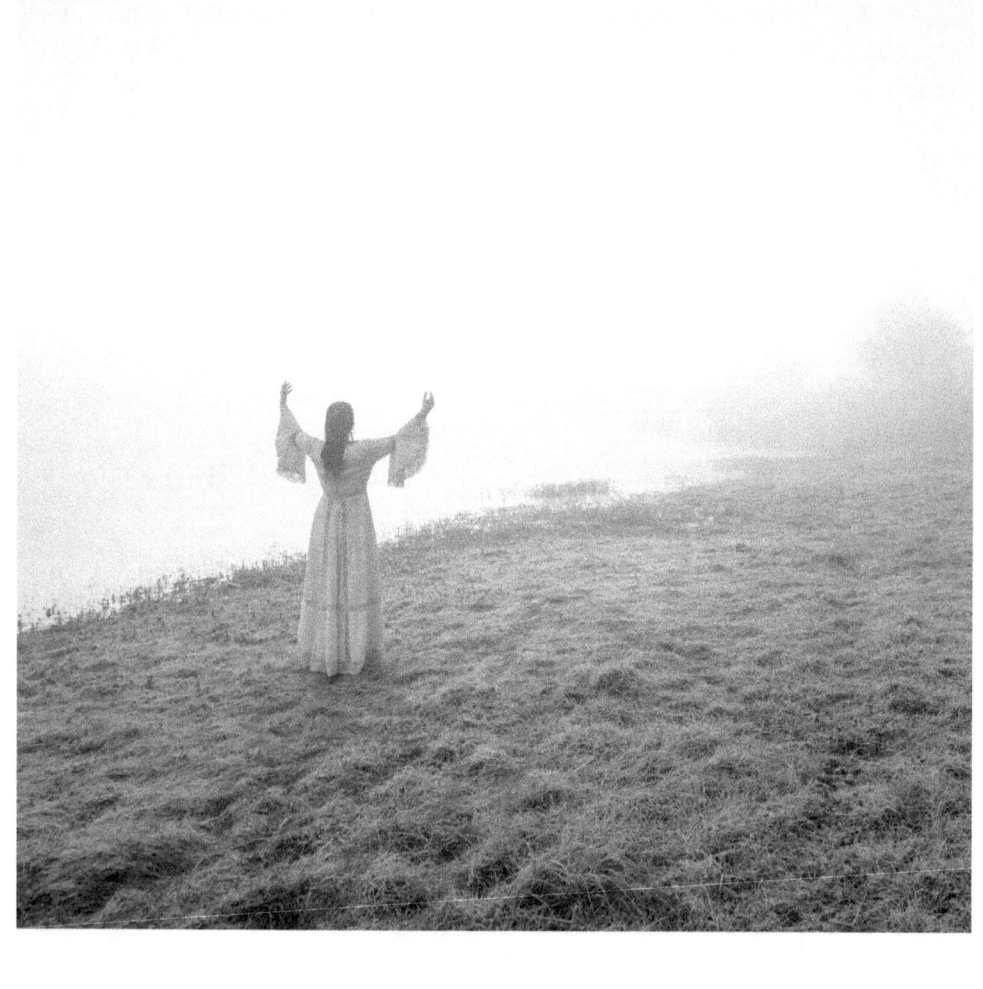

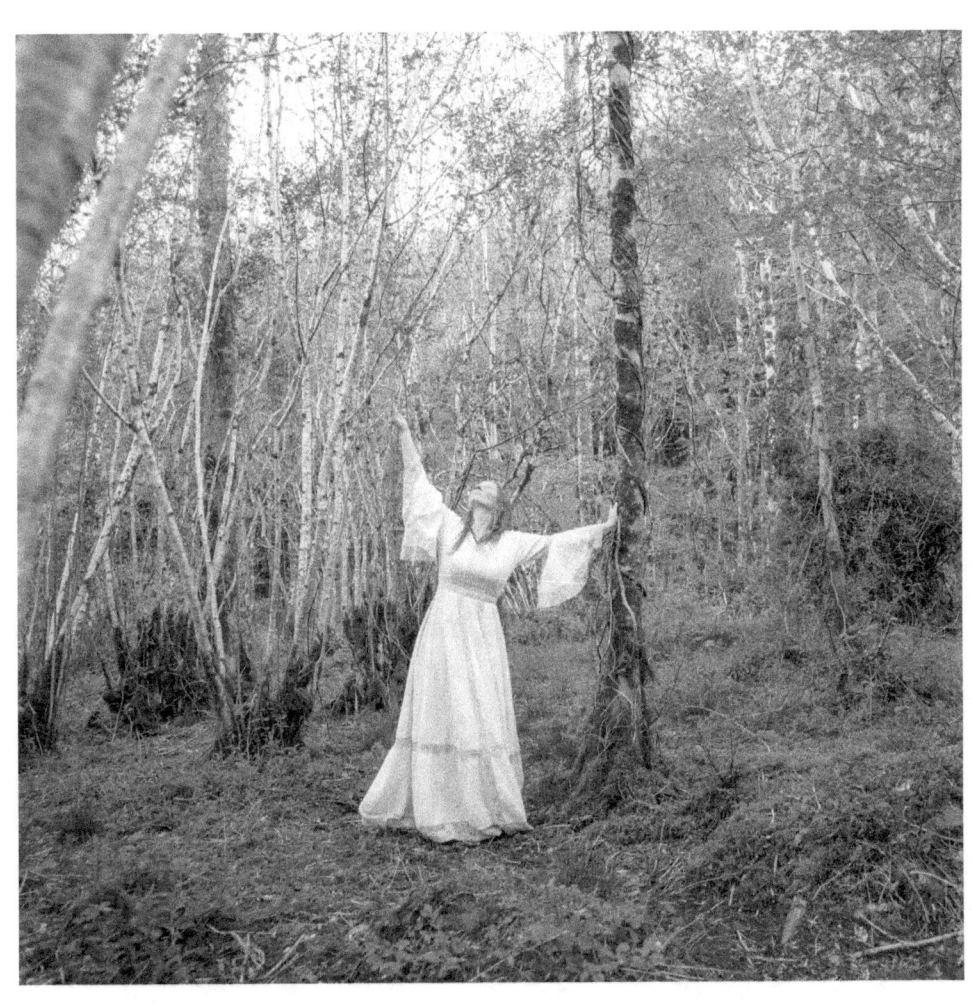

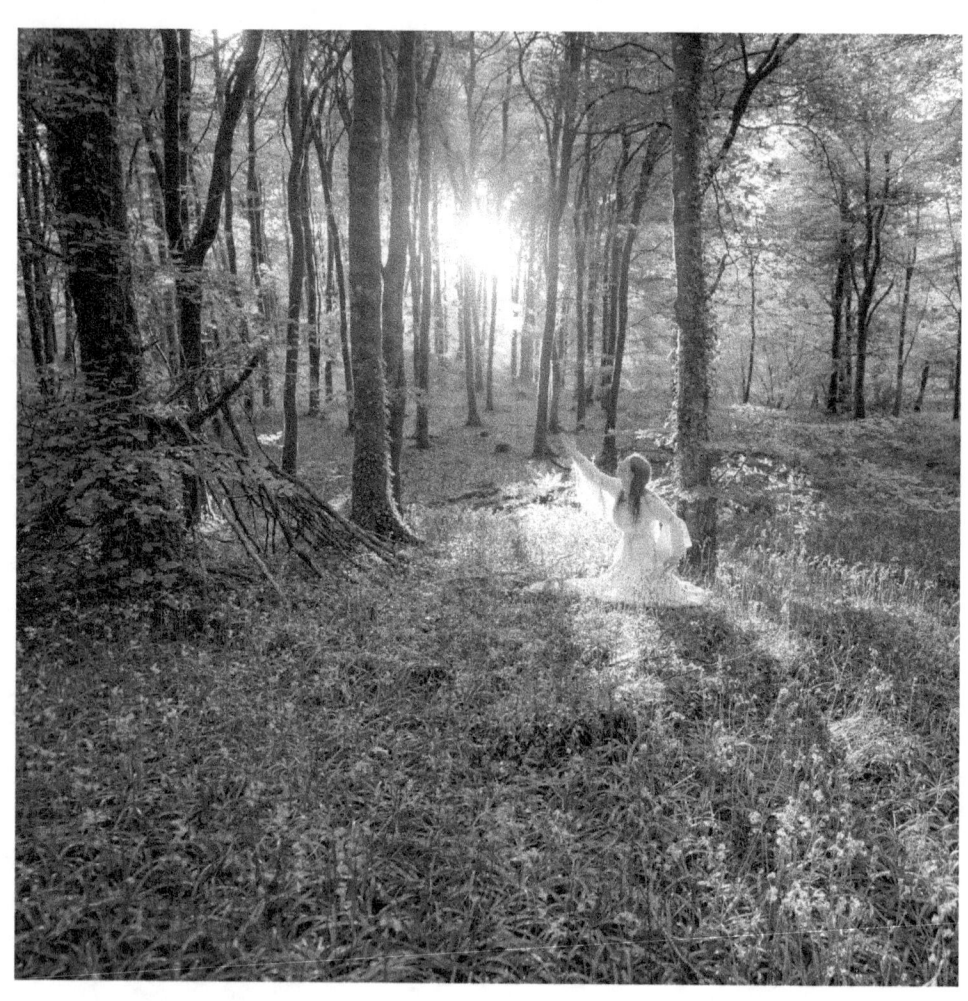

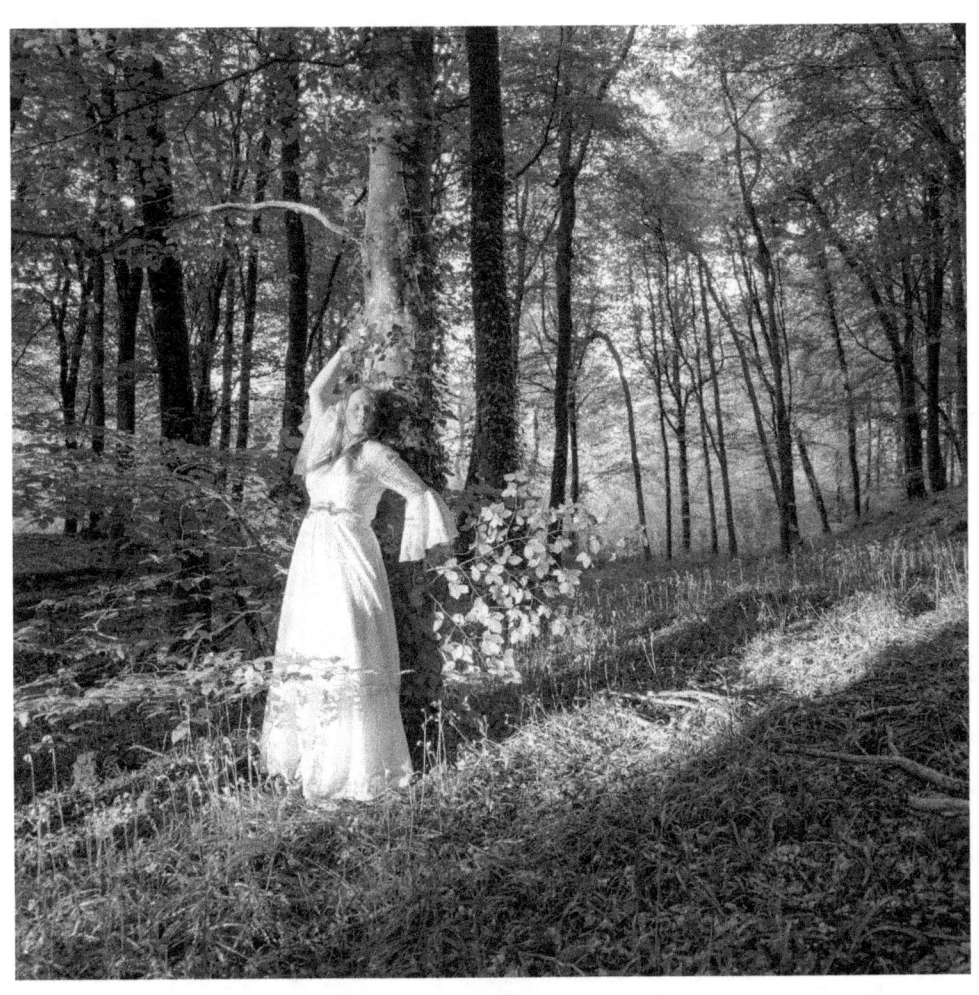

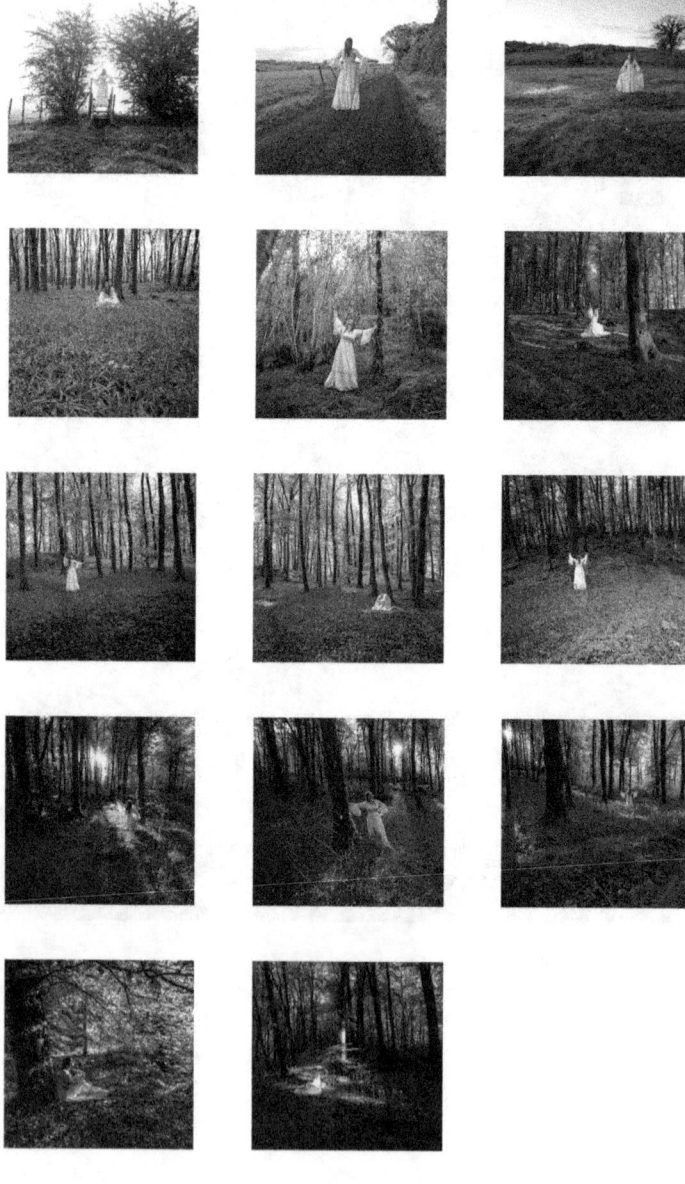

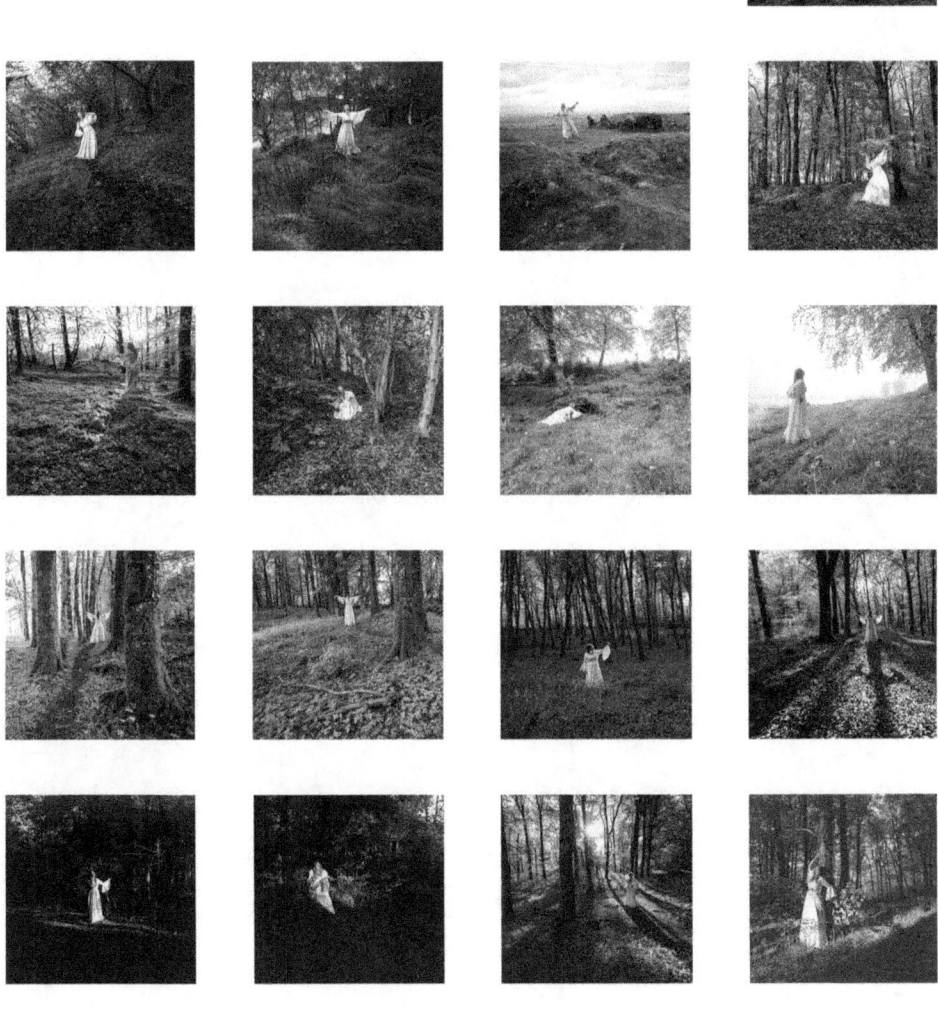

Europe Dresses Mourning

by José Luis Lozano
made by Hugo Zelado-Romero

 Flags, dye

Today the white flag is identified as a sign of surrender, ceasefire or intention to negotiate, and this was reflected in the regulations of war derived from the Hague Conferences of 1899 and 1907, and in the Geneva Conventions. currently in force. The white flag marks a ceasefire, a potentially visual symbol to claim peace. But also, the color white has its meaning among Buddhists, it is a sign of mourning, white is a sign of death, of all the people who risk their lives to cross political borders in search of better conditions. In this case, the flag is dyed with mourning, for all the people who risk their lives daily to enter Europe through the Mediterranean Sea that separates both continents and as a safe conduit, the patera, a boat that in precarious conditions sails between the waters adrift waiting to reach a world of hope and change.

- José Luis Lozano

The collaborative project *Europe Dresses Mourning* proposes to dye the flags of the countries that make up the European continent black. To do this, the artist/collaborator will receive a kit by parcel service that contains:

a) Bag of flags from all European countries
b) bag of black dye ink
c) Instructions for use

Once the material has been received to start the proposal, the artist must dye the flags black, let them dry in the sun for 24 hours and then hang the black-dyed flags on a terrace or balcony that are visible in the public space where people of the public can see them.

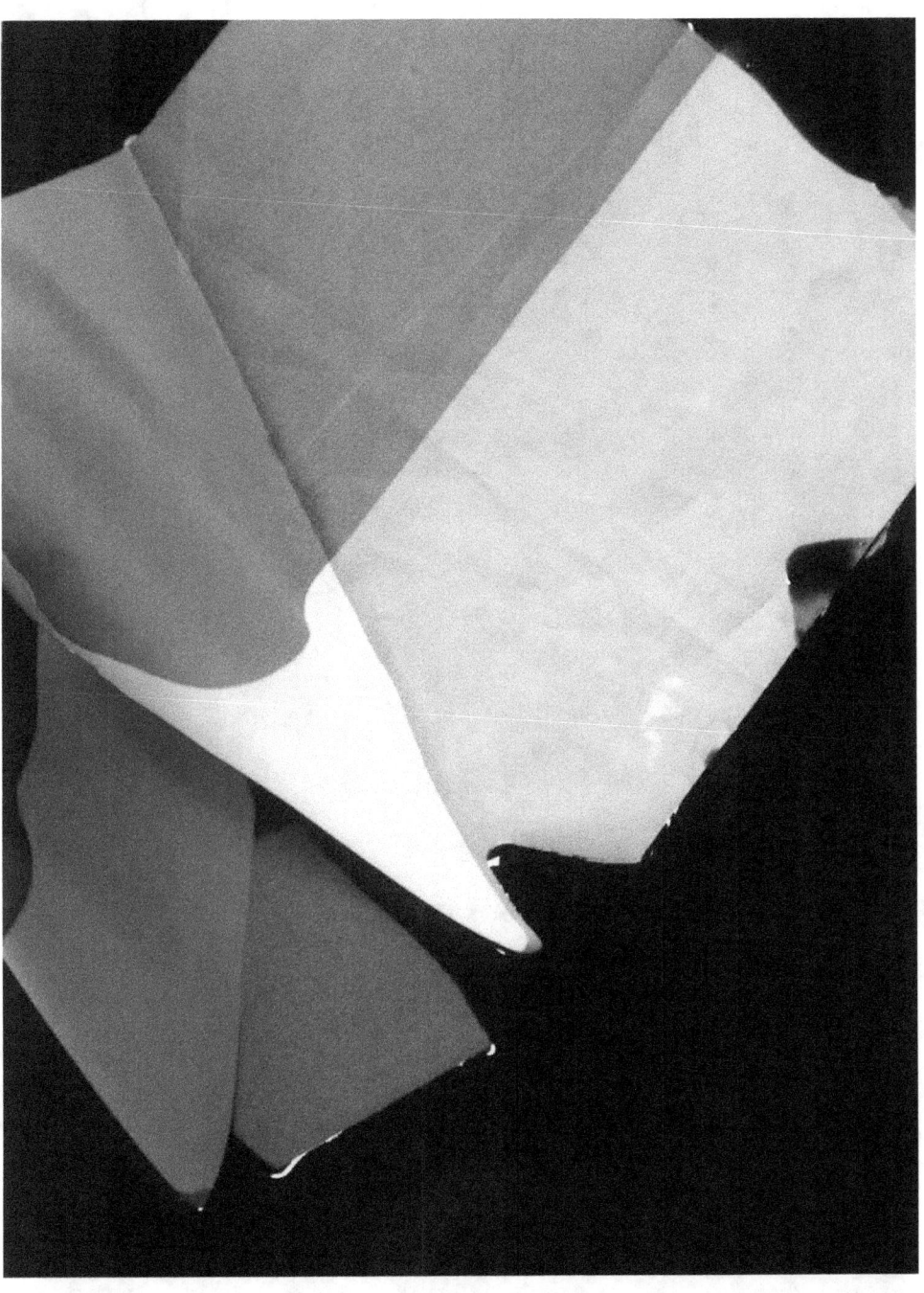

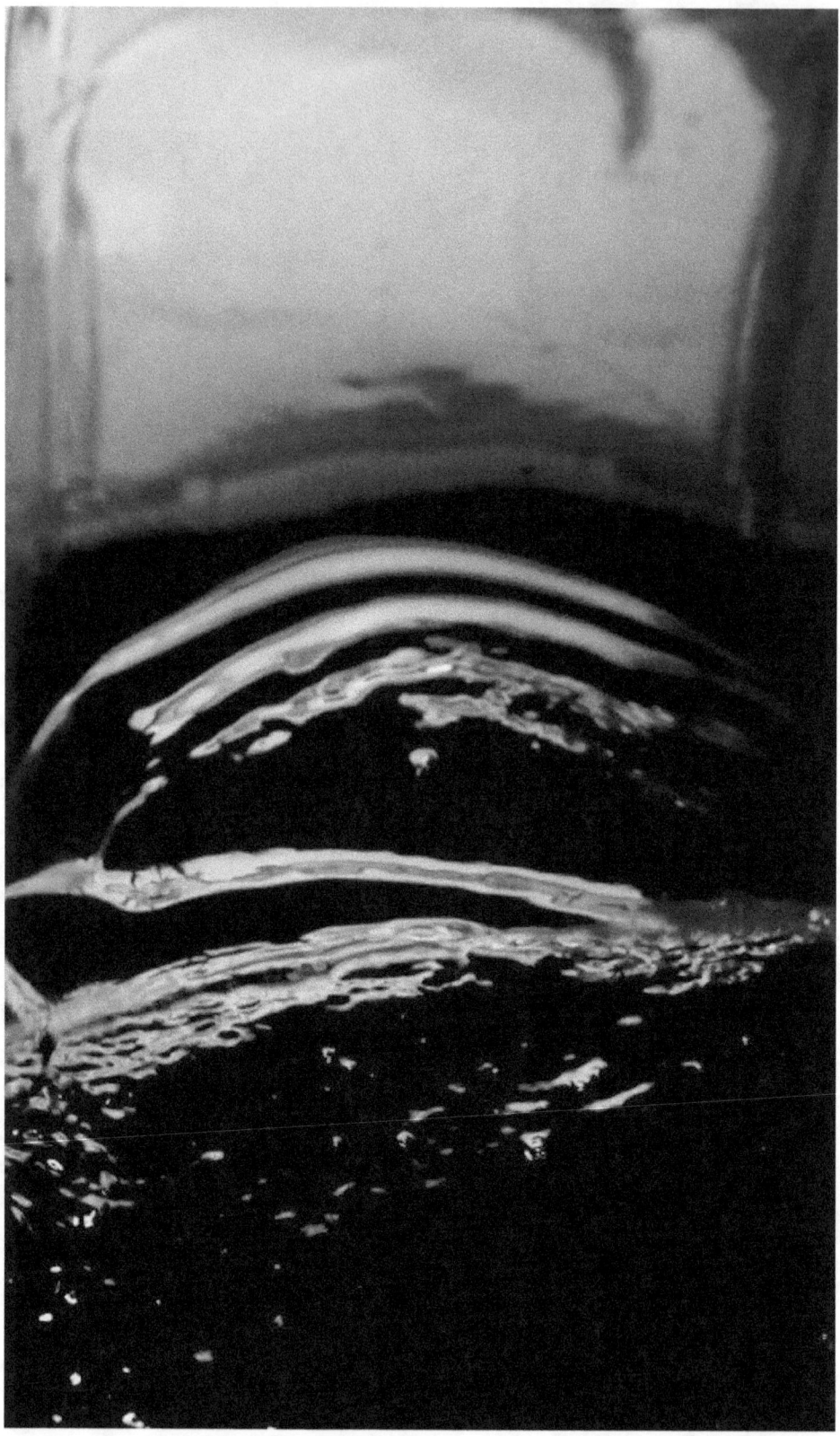

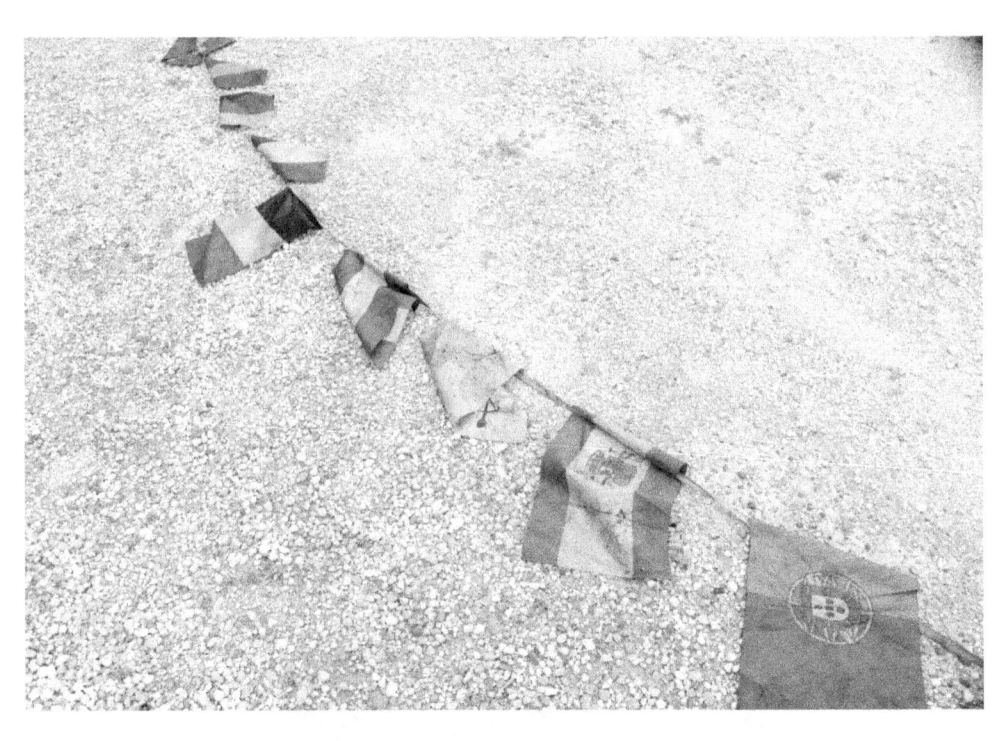

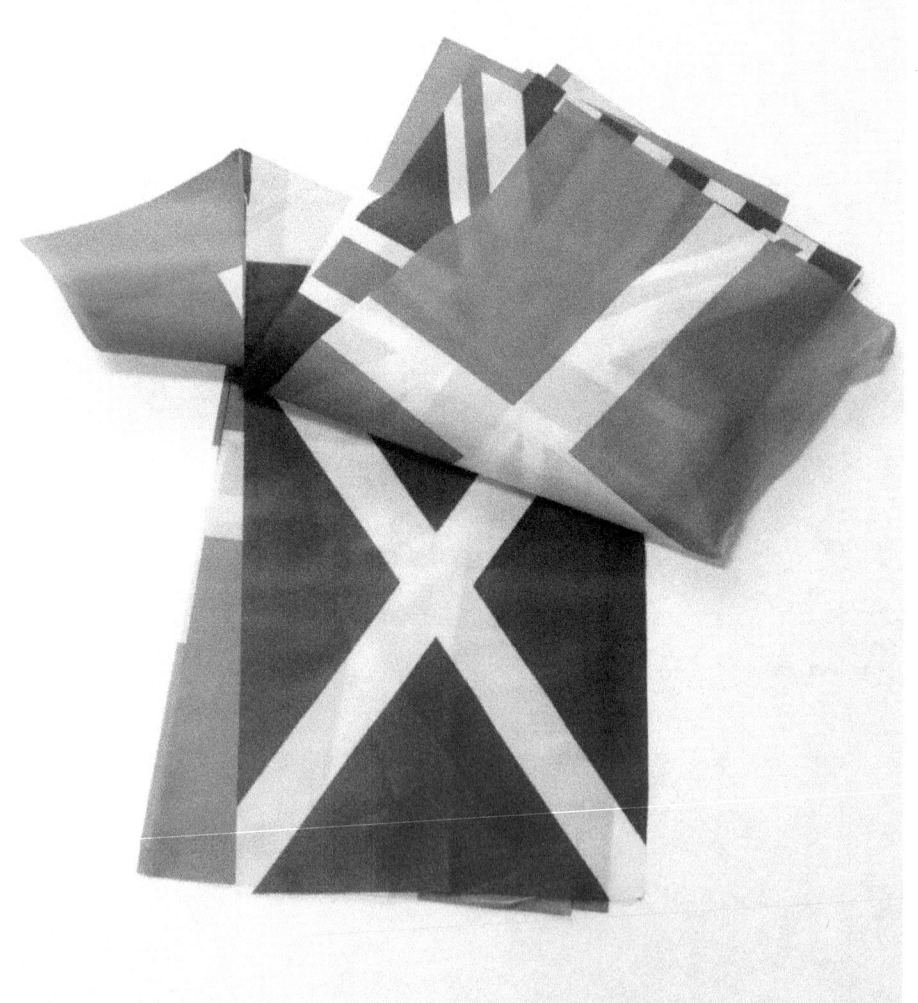

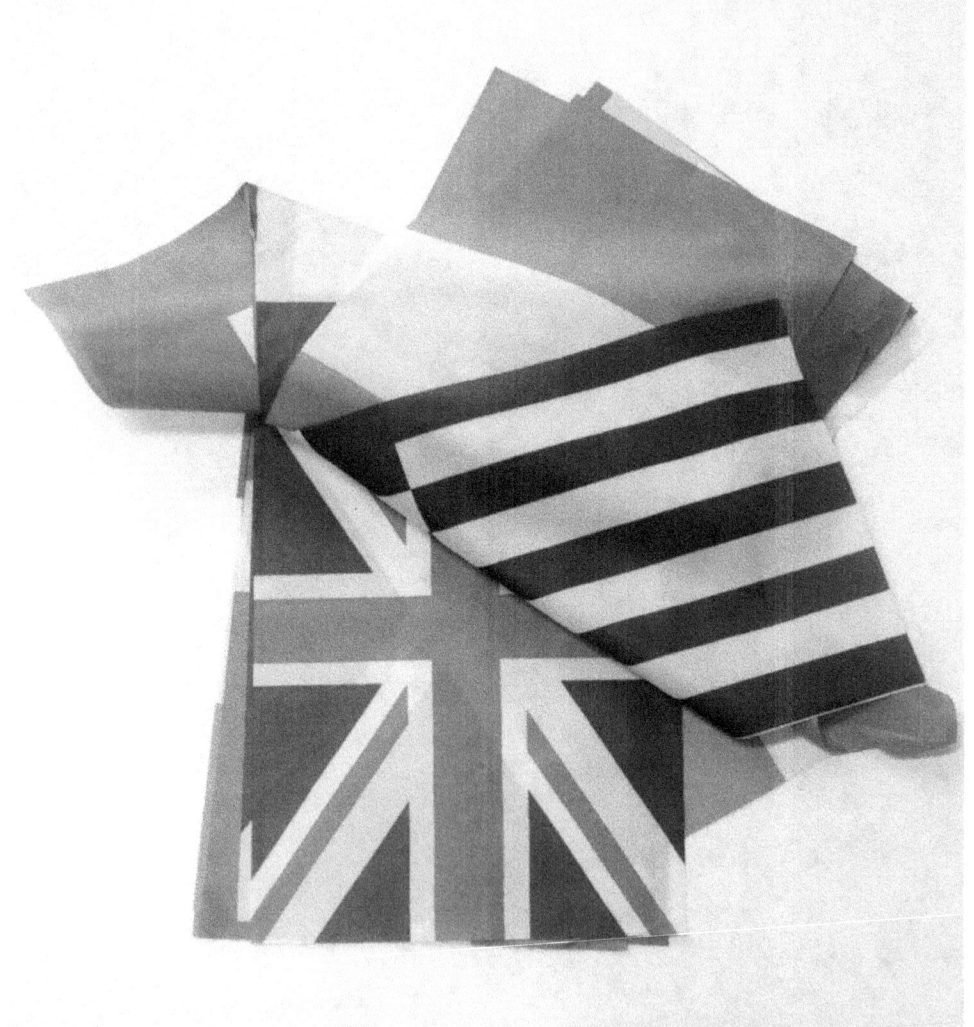

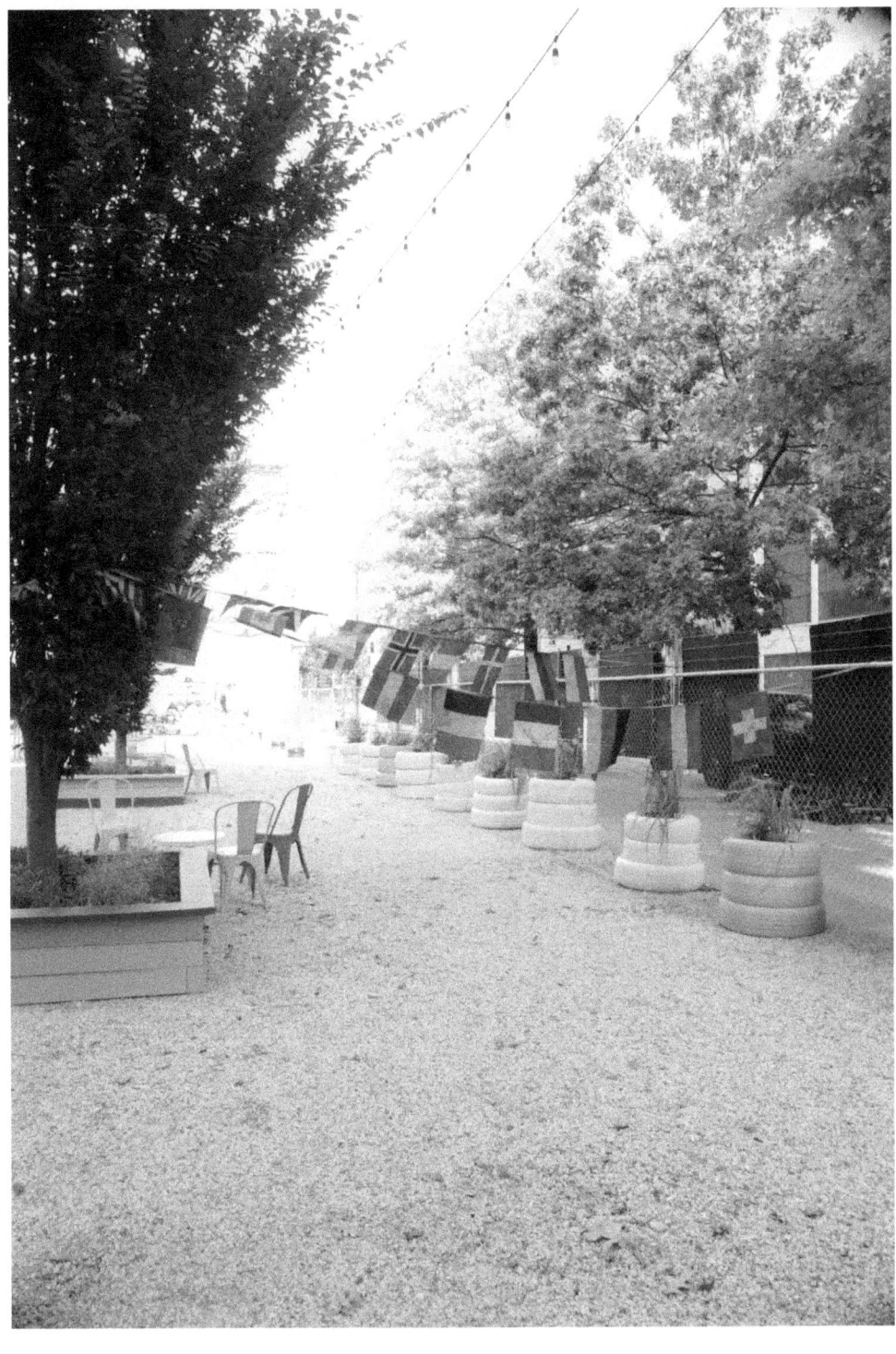

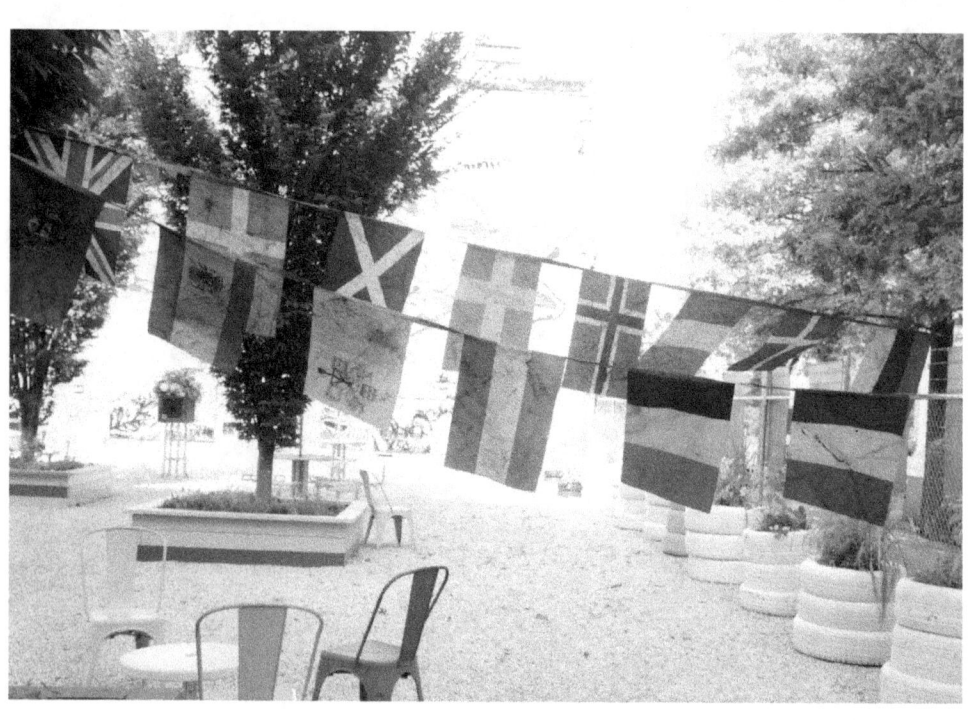

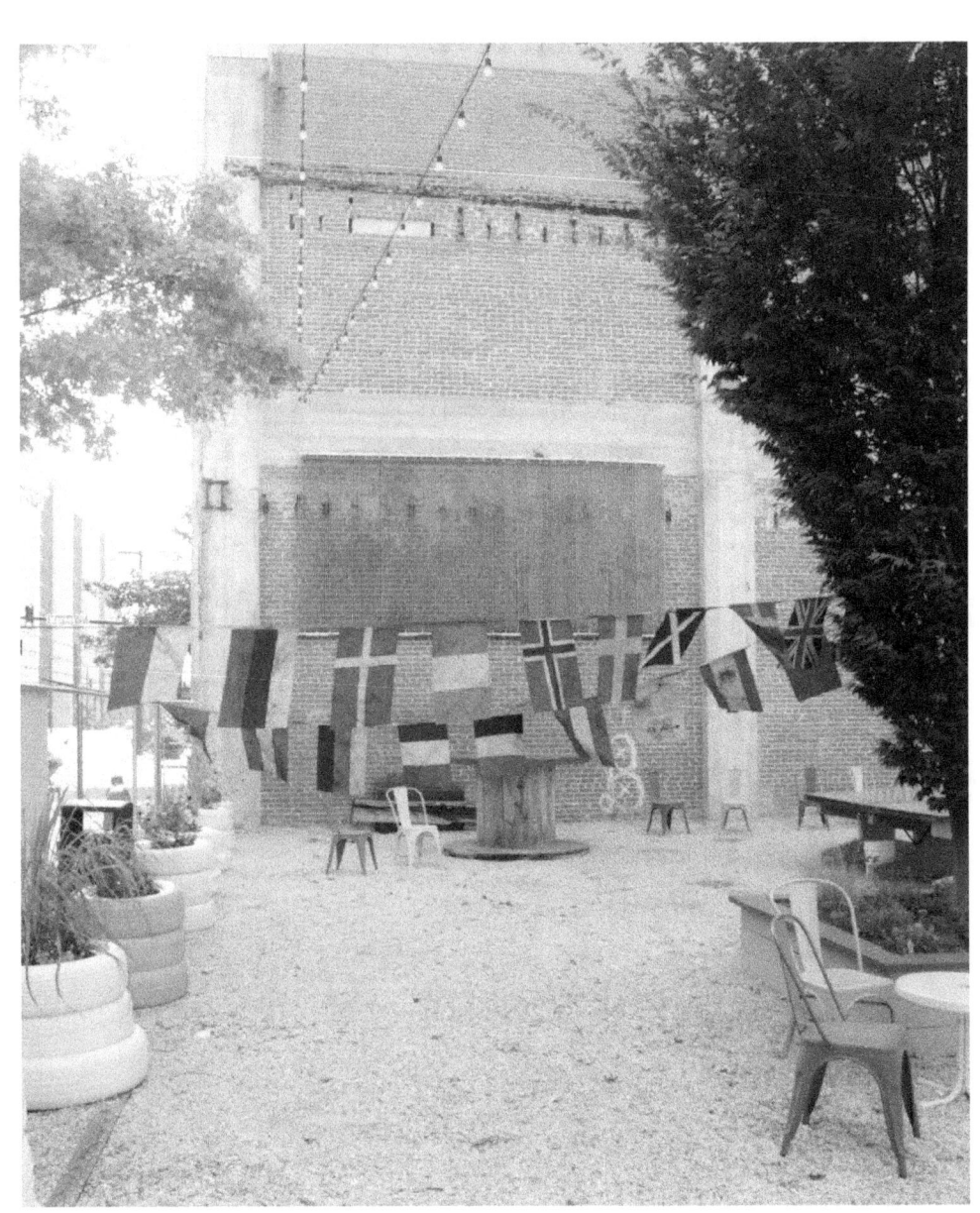

By the Waters of Babylon

by Hugo Zelada-Romero
made by Jesse Allen

 Water, performance

Gather one large 1-2 gallon water dispenser, ideally one that is clear. Gather several different brands of water bottles. Empty the contents into the water dispenser. Serve during a gathering, event, or present as an interactive sculpture in an exhibition. Serve in small tasting cups or any small drinking container. List the ingredients (brands of water bottles) in any manner. This could be a nicely printed list, as part of the material in a title card, or the bottles may be displayed in any fashion. It is only necessary to convey that the water dispenser is a mixture of different bottled water brands. Periodically add water from any water bottles as the water supply begins to dwindle so as to always appear nearly full.

- Hugo Zelada-Romero

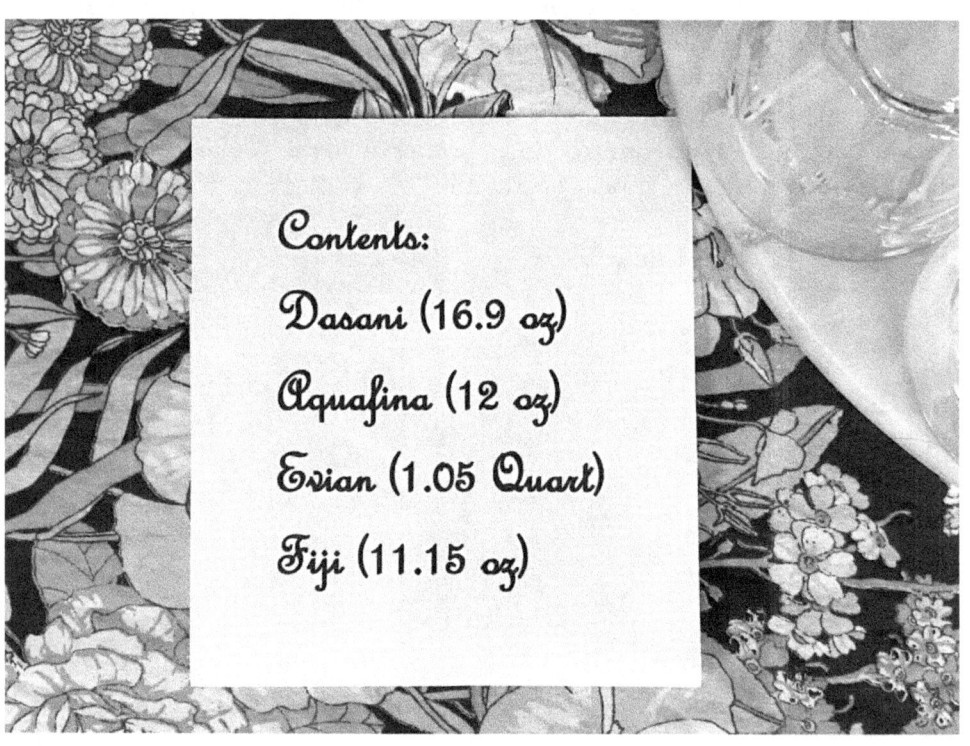

Contents:

Dasani (16.9 oz)

Aquafina (12 oz)

Evian (1.05 Quart)

Fiji (11.15 oz)

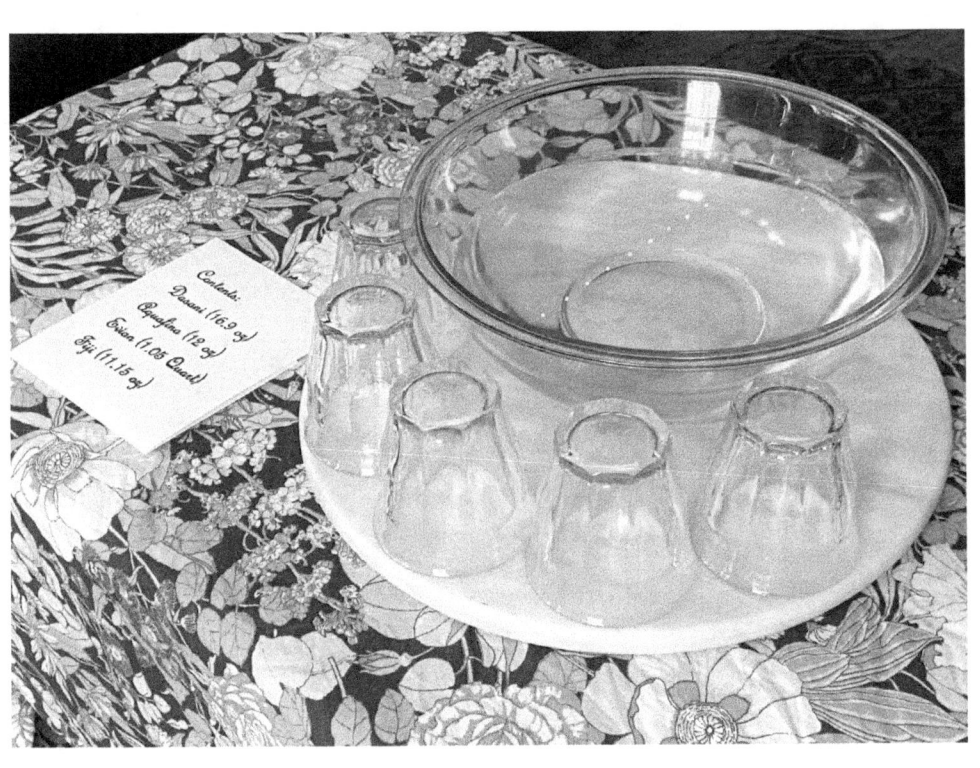

A Collecting Walk

by Sue Uhlig
made by Rumplestiltskin Morgan

 Mixed media

A collecting walk is a purposeful gathering of things through movement within a place. Take one walk or a series of walks by yourself or with others to collect 20 things that reflect evidence of being, a connection to place, and/or the vibrancy of the found objects. If desired, use gloves and/or tweezers to pick up the objects. Once you collect 20 things, spread them out and study the objects, then experiment in arranging them in different ways to showcase their vibrancy.

- Sue Uhlig

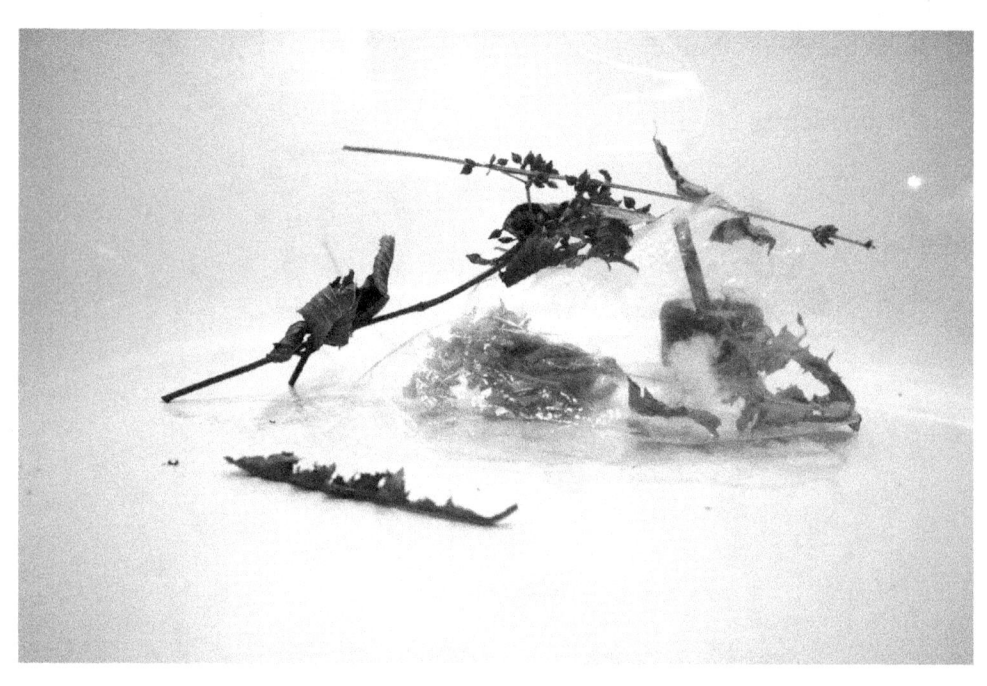

Twig	Viburnum stem (dried)
Hydrangea section	Unknown plant material
Popsicle stick	Clear Plastic film (crunchy)
Maple leaf	Woodchip
Wild strawberry	Newspaper bit
Unknown plant material	Dandelion leaf
Small yellow leaf (dried)	Woodchip
Maple leaf	Stone
Lavender stem	Ceramic cup
Dandelion leaf	Unknown plant material

Over the course of two walks, I collected 20 items, a combination of organic and inorganic material. The majority were plant materials such as fresh dandelion, a section of a hydrangea flower, or dried leaves from Autumn. Inorganic items collected include a clear piece of plastic, a small polyester puff, and other human made trash.

During the process, I found myself primarily drawn to neutral toned items, with the exception of the dandelion leaves. In their subtlety a strong connection to location and history, both past and future radiated. The interwoven existences with each other and human and non-human occupants of my neighborhood (location of the walks) was present in their materiality in that they were derived from organic materials and/or mimicked organic forms that rather seamlessly flowed into the domestic space.

The arrangement of this collection was inspired by the balance and performative nature of connection to place. This final location of my shower allowed them to exist in a sterile-like space with denied access to the drain, an exit from the house within reach. Reflections on the surface of the shower serve as further acknowledgement of coexisting within an isolated arrangement, enhancing the vibrancy (power of presence) of each item and the collection as a whole.

- Rumpelstiltskin Morgan

99 Word Meals: Second Breakfast

by Rumpelstiltskin Morgan
made by Grigoria Vryttia

 Text, performance

Borrowing poetic forms to aid the translation of recipes into the arrangement of the everyday as ritual. Each writing works within the preparation of a specific food or meal, and allows the conscious to permeate the process, creating pockets for the reader / maker of the "recipe" to interpret, inviting collaboration. The five courses are served in a printed format for consumption.

- Rumpelstiltskin Morgan

A RECIPE FOR A LONG COURSE

Food. Food is not only sustainance but pleasure too.

For Greeks, to offer food is a sign of care. The stereotypical Greek mother will always advise you to take your cardigan with you when you leave the house and go through great lengths to give food to her children

I have been the witness of 50 year old men with their own famillies, receiving packets of traditional foods, from their parents who live 800 km away.

I do not come from such a familly.

Yet I have this relationship with food. I offer food to people I care about and one can tell if I am angry with them as I will do the opposite. I have dozens of recipes memorized but my sister always asks for the simplest and most basic : pasta with red sauce

Pasta with Red Sauce:

Start with the sauce:
Chop onions and garlic. In a saucepan warm some olive oil in low heat. Add the chopped vegetables and let them release their fragrance in the oil. Start boiling water for the pasta. Add some tomatoe-purée to the vegetables plus salt, pepper, dried basil and marjoram. Perhaps you might have to add some water. Stir and let it simmer. When the water has reached the boiling point, add salt and a drizzle of olive oil, and the pasta. Stir and let them cook. Serve with grated cheese.

Although this is a very basic recipe, it needs your full attention as the pasta should be stired often and the sauce should cook slowly.

My sister sais that my food tastes like no one else's. I tell her that my secret ingredient is my love for her, that is reflected in the dish.

Recipes are instructions but cooking requires feelings

The project I was invited to complete was a great challenge for me as text-based work puts me outside my comfort zone.

And yet, there was such a great part of this project that made me feel a connection to the person whose idea this was.

There are occasions when I feel that our perception of art is so directly linked to all of our senses that cooking and enjoying food can be an important aesthetic experience.

To that I added a personal tone and registered recipes that has an emotional value for me.

The final work is to be consumed visually, as Rumpelstiltskin Morgan suggested.

The additional beauty of this piece is that, if one decided to follow my recipes a further link will be created.

Thank you for the opportunity to realize this.

- Grigoria Vryttia

alastriapress.wordpress.com

www.ingramcontent.com/pod-product-compliance
Lightning Source LLC
Chambersburg PA
CBHW072155170526
45158CB00004BA/1661